TREASURES OF
ROMAN YORKSHIRE

ADAM PARKER

AMBERLEY

I dedicate this book to Orla.

First published 2023

Amberley Publishing
The Hill, Stroud,
Gloucestershire, GL5 4EP

www.amberley-books.com

ISBN: 978 1 3981 0510 2 (print)
ISBN: 978 1 3981 0511 9 (ebook)

British Library Cataloguing in Publication Data.
A catalogue record for this book is available from the British Library.

Typeset in 10pt on 13pt Celeste.
Typesetting by SJmagic DESIGN SERVICES, India.
Printed in the UK.

Contents

Preface

In 2019, I published the book *The Archaeology of Roman York* with Amberley Publishing. I must thank them for providing a platform for that volume. Roman archaeology is my passion, and after many years of working hands-on with York's incredible archaeological remains it was both my pleasure and privilege to have written on this topic. In this sort of sequel I have expanded beyond York to include all of Yorkshire in the Roman period. I hope that this book will also meet a need in the current resources for interested people to learn about what happened in this part of Britain in the first four centuries AD.

For *Treasures of Roman Yorkshire,* it is important to define 'treasures' here at the outset. In terms of heritage law in England and Wales, treasure is any object older than 300 years that is more than 10 per cent by weight precious metal. This is set out in the Treasure Act 1996, which also identifies the other forms of treasure. While several examples of what is legally classed as 'treasure' appear in the following, what the word means here is much more encompassing. Treasure is something that was once hidden, and which is now precious, and this definition covers a lot of Roman archaeology. The treasures I am discussing are the interesting and unique objects, groups of objects, people, and places from Roman Yorkshire. As much as possible I have used case studies to demonstrate aspects of the different themes that are addressed and all of these, both individually and together, are certainly treasures.

There are, of course, plenty of people to thank. First and foremost is Antony Lee, author of *Treasures of Roman Lincolnshire* (Amberley, 2016) for warmly greeting my suggestion to create a parallel book using his title to cover Yorkshire, and thanks also to the folks at Amberley for agreeing to work with me again. Thanks to Northern Archaeological Associates, Malton Museum, Hull and East Riding Museums, the Centre for the Study of Ancient Documents, and the Historic Towns Atlas for providing images free of charge to supplement the text. I must thank again my fellow archaeologists and historians at the Yorkshire Museum and the Portable Antiquities Scheme for commenting on individual objects and for providing references, and, especially, to Emily Tilley for commenting on an earlier draft. I remain always indebted to the fabulous Katherine Hughes for continuing to endure my passion for history.

On a serious note, a good portion of the text of this book was written during the Covid-19 pandemic in the spring and summer of 2020, facilitated by my furlough leave from the Yorkshire Museum. This horrid virus affected all of us in some way and took away many people before their time; we should remain ever thankful to our NHS, emergency services and all the frontline workers throughout society that continued to make our lives safe during and beyond the lockdown. I know from first-hand experience that the arts and cultural venues (museums included) took yet another financial beating during this time – please do help them out by visiting, buying the guidebook, or even just following them on social media and helping them spread the good word.

I hope that this book proves to be interesting and that it can be a useful reference to the incredible archaeological remains of Roman Yorkshire.

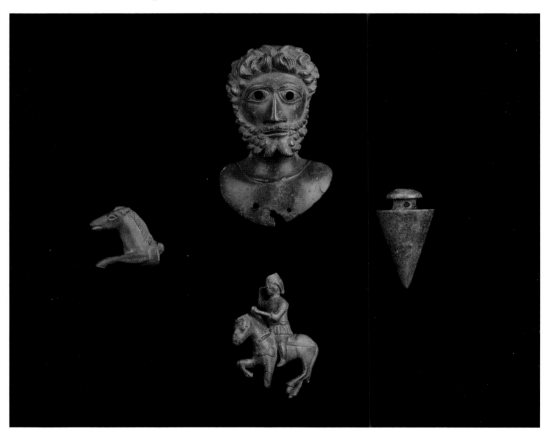

This unique hoard of copper alloy objects was found in Ryedale in 2020. The four objects buried together are a sceptre-head in the form of a bust of Marcus Aurelius; a horse-head key fragment; a figurine of the god Mars as a cavalryman; and a plumb bob. It was acquired by the Yorkshire Museum in 2022. © York Museums Trust.

Introduction

The invasion of Britain by the Romans in AD 43 fundamentally changed the course of history on these islands. For better or worse, the invaders conquered, expanded, constructed, and consolidated until they occupied most of what is now England and Wales as well as, occasionally, parts of Scotland. This book focusses on the Yorkshire region in the Roman period in Britain (AD 43–410) and Yorkshire itself represents a significant part of Roman Britain. By Yorkshire I mean the ceremonial counties of North Yorkshire, West Yorkshire, South Yorkshire, and the East Riding of Yorkshire. These geographical boundaries are historically complex but didn't exist in the Roman period. Their presence in modern civic administration, as well as modern imagination, is reason enough to talk about what came before in these places. The historic county of Yorkshire was the largest in England and so by highlighting the Roman influence and interventions in this area we will, inevitably, discover a great deal about the archaeology of Roman Britain as a whole.

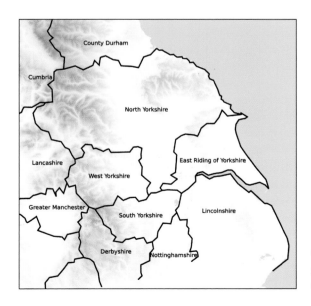

The four counties of Yorkshire in northern England (UK). Areas of high elevation appear as dark shading.

Landscape

The boundaries of what constitutes 'Yorkshire' have been repeatedly redrawn and are (from the Roman viewpoint) somewhat arbitrary. Despite their historic fluidity, the focus here is on the boundaries of the four modern counties of Yorkshire. This has led to sites being omitted here, which may have been regarded as within Yorkshire in the mid-twentieth century or earlier. In this category we can, for example, count the forts at Bowes and Greta Bridge (now in County Durham), and at Castleshaw (now in Greater Manchester).

Within the modern administrative boundaries of the four Yorkshires, the landscape is quite varied. There is an extended lowland zone, the Vales of Mowbray and York, running in a wide curving band from the River Tees in the north to the Humber in the south. This is flanked by the uplands for which Yorkshire is most familiar – rolling hills and dramatic river valleys. There are numerous rivers flowing from these upland areas: Swale, Ure, Nidd, Wharfe, Aire, Ribble, Calder, Dearne, Esk and others. Some join together into the Derwent, Ouse and Don, and most end up in the Humber. The Humber is a tidal estuary that widens as it heads east until it meets the North Sea. Many of these rivers flow through the other lowland zones of the Vale of Pickering, the Humberhead Levels, and the area around Holderness. The routes and heights of many rivers were different in the Roman period thanks to slightly differing climate and environmental factors as well as the obvious human ones. As a case in point, the rivers in York, the Ouse and Foss, now flood seasonally in a different way thanks to flood defences and built-up banks. All of these landscape features informed the location of roads, forts, towns, and farms in Roman Yorkshire.

Rolling hills in upland Yorkshire: Swaledale, looking south-east from the Pennine Way. (Courtesy of Kreuzschnabel, CC BY SA 3.0)

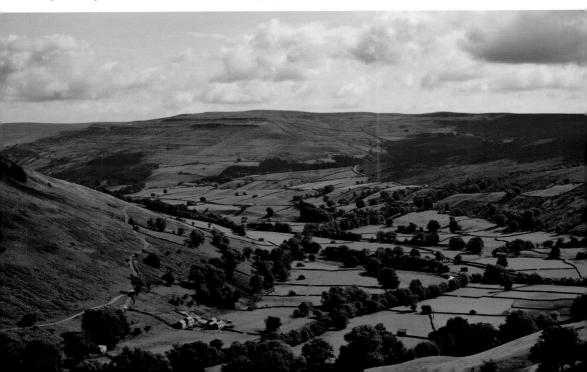

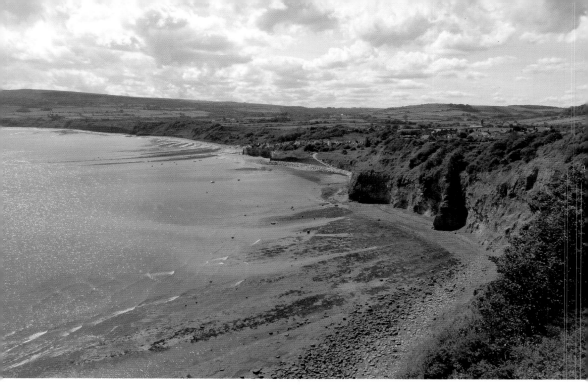

Above: Sea, cliffs, and hills. Robin Hood's Bay is situated between Whitby and Scarborough. (Courtesy of Anthony Fost, CC BY SA 2.0)

Below: The River Wharfe at Ilkley on a dramatic autumn day. The Roman fort was situated near the river. (Courtesy of Mtaylor848, CC BY SA 4.0)

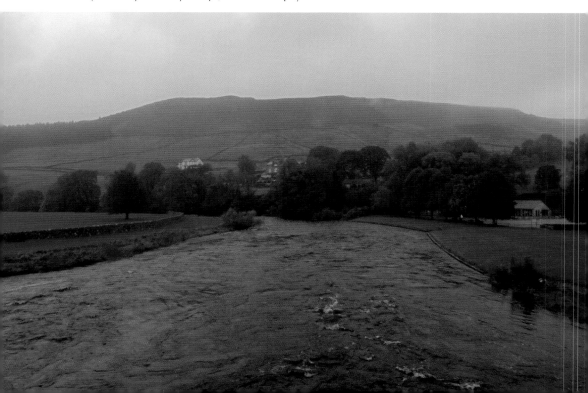

Invading Yorkshire

The foundations of Roman Yorkshire were formed in the second half of the first century AD, especially in the period *c.* AD 70–100.

The invasion of Roman Britain began in AD 43, with four legions landing on the south coast, probably at Richborough in Kent. An earlier invasion by Julius Caesar in 55/54 BC was short-lived. The purpose of the AD 43 campaign served the dual purpose of expanding the edges of the Roman Empire and providing the new Emperor Claudius (who came to power in AD 41) with a much-needed military victory. The island of Britain offered mineral wealth, land for development, and a total population estimated at around 500,000 to 1,000,000 people – potential allies, potential taxpayers or potential captives for the Roman Empire.

Britain was in the period commonly referred to as the 'Iron Age' at the time of the invasion. Iron Age peoples were loosely grouped into large populations or tribes, the names of which we hear about from coins and the surviving texts of a number of Roman writers. The earliest military campaigns of AD 43 focussed on the Catuvellauni and Trinovantes tribes in the south and south-east of Britain with the initial goal of crossing the River Thames and attacking the regional capital of Colchester. Emperor Claudius, famously complete with a detachment of elephants, was personally present during the siege and fall of Colchester and declared the campaign a success. However, the invasion of the province of Britain continued for decades after AD 43.

In the mid-first century AD much of the area of Yorkshire was under the control of the Brigantes, an Iron Age tribe, whose lands extended across northern Britain. Their Queen Cartimandua was friendly to the Roman invaders and acted as a 'client-queen' – her lands were left free in return for loyalty to Rome. For capturing Caratacus (the figurehead of the anti-Roman faction during the invasion period) the Roman writer Tacitus recorded that Cartimandua was given great wealth by Rome.

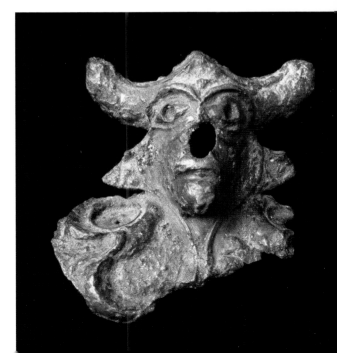

The artistic style present on this object might be Brigantian. It is from the invasion period of the late first century AD. It was found in 1794 in the foundations of the city walls of Aldborough. In the Yorkshire Museum. (© York Museums Trust, CC BY SA 4.0)

The Brigantes eventually gained a reputation for civil unrest and revolt, but all-out war between Rome and the tribes of the north in the middle of the first century was certainly delayed, if not prevented, by the relationship between Cartimandua and the Roman governors of Britain. This was not to last. In AD 57, Cartimandua divorced her husband Venutius and instead took his armour-bearer, Vellocatus, as her husband. Venutius began an uprising against the queen and eventually against the Roman army in the region. This first rebellion was defeated by the 9th 'Hispanic' Legion (Legio IX Hispana), but Venutius remained alive. In AD 69, Venutius again rebelled, causing Cartimandua to appeal to the Roman government for help – the army managed to evacuate her from the area, after which no more is heard of the queen in the historic records.

This political upheaval and the continuing anti-Roman sentiment of Venutius influenced the establishment of a large and permanent military garrison in the area and this historical background was the genesis of the city of York. AD 70/71 is the time that the city was established as a Roman fortress, but it was a reaction to a political issue rather than a carefully considered choice by the Roman army. The site chosen was a plateau where the River Foss and the River Ouse joined, and which was navigable by boat all the way to the coast. This site is also situated near to a probable tribal centre of the Brigantes at Aldborough (30 miles to the north-west) and near to the tribal lands of the Parisi – the other, smaller, Iron Age population in the area based in East Yorkshire. From this point onwards a series of campaigns were launched against the Brigantes, initially by the then Governor of the Province Petilius Cerialis (governor AD 71–74). While there were earlier forts in Yorkshire, at Templeborough near Rotherham for example, and some roads it was the presence of a permanent legionary fortress in York that really cemented the foundations of the Roman presence in this part of Britain.

Stanwick – Cartimandua's Capital?

There is certainly evidence to suggest that Aldborough was an important settlement for the Brigantes, but the huge settlement at the very northern edge of North Yorkshire is often forgotten. Stanwick held a prominent regional position in the early years of Roman invasion of Yorkshire. The modern village of Stanwick St John is at the centre of what was a heavily fortified Iron Age settlement. We might technically describe it as a hill fort, but it isn't really at the top of a hill like other Iron Age enclosed settlements. Excavations in the 1950s by Sir Mortimer Wheeler led him to thinking of Stanwick as the stronghold of Venutius used in the fight against Roman invasion. Recent thinking has changed this understanding – there is a considerable amount of Roman material culture imported into the Brigantian site from the AD 40s–70s that suggests a demand and a market for these exotic goods. It may have been the capital while Cartimandua was in power as a client ruler.

A central part of the site is known as the Tofts. The immediate landscape surrounding it was extensively defended by banks, ditches, and fortifications. The Tofts were first occupied from 80/70 BC to 30/20 BC in the form of a few buildings. This was subsequently surrounded by a ditched enclosure and an earthen bank. From AD 30/40 the huge defensive earthworks were built putting it on a par with large Iron Age sites in the south,

Part of the huge earthen defences surrounding the Iron Age settlement at Stanwick St John. This is a section originally of the eastern section, near to the modern village. (Courtesy of Graham Scarborough, CC BY-SA 2.0)

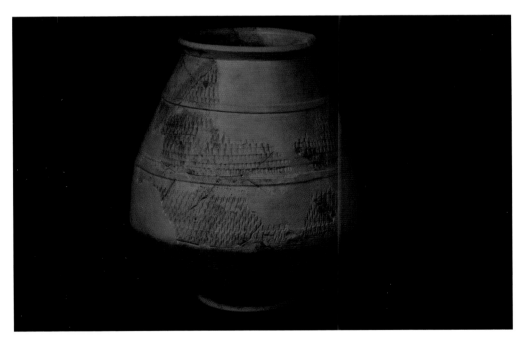

This unusual ceramic beaker from Stanwick displays elements of Iron Age and Roman pottery traditions, highlighting the beginnings of cultural exchanges. In the Yorkshire Museum (YORYM: 1957.5.1). (© York Museums Trust, CC BY SA 4.0)

like Colchester and St Albans. The outer defensive earthworks were stone-faced (itself unusual) and ran for 6.8 km (4.2 miles) in length, enclosing an area of 270 hectares (667 acres). This was a huge settlement. No other Iron Age site in the north of England comes close to the size of Stanwick. The exotic material culture imported into Stanwick included a lot of Samian ware pottery produced in southern Gaul (France), fine glass vessels, and even an obsidian cup.

1

A Military Presence

During the early stages of the invasion of the region and before any permanent base was constructed, the various units of the Roman army constructed temporary camps. These camps were large structures, usually rectangular in shape, which had an earthen bank and ditch surrounding them as well as a wooden palisade fence. A temporary camp was a fleeting structure as they could be constructed at the end of a day's march and abandoned as soon as the day after. There is often very little to see on the ground today, but aerial and satellite photography has allowed us to find several in Yorkshire. For example, we know of camps at Rossington, Malham, Cawthorn, Breckenbrough, and Brompton-on-Swale.

Leeds and Sheffield are, in the twenty-first century, Yorkshire's most populated places, followed by York, Barnsley, Huddersfield, Doncaster, Rotherham, Halifax, Wakefield and Harrogate. In the Roman period York was probably the largest settlement in the region by population as it was the permanent base for the 9th Legion and, later, the 6th Legion, each with over 5,000 soldiers. Many sites, especially forts, were abandoned at some point during the Romano-British period and didn't last until its end in the early fifth century AD. Some forts came into and out of use or were occasionally rebuilt from the ground up. The settlements, towns and villas also suffered the same changes in fortune, expanding and contracting organically over the period.

The Roman army was divided into two main branches – the legions and the auxiliaries. Both were professional soldiers but were categorised by different legal statuses. At the time of the invasion a legionary was a free Roman citizen, recruited under the age of forty-five, who enlisted in the army for a period of twenty-five years, and was organised into a legion of 5,000–6,000 men. An auxiliary was, legally, a non-citizen, recruited to fight in the support wing of the Roman army and eventually rewarded with citizenship for himself and his children after twenty-five years of service. Auxiliaries were organised into units called *Cohors* (Cohorts) or *Alae* (Wings) of around 500 men. It is a fallacy to think that all Roman soldiers were from Rome or, indeed, from Italy. Research has shown that in the first half of the first century AD, nearly 65 per cent of Roman legionaries were recruited from Italy, a figure which had reduced dramatically to less than 1 per cent by the second century – Roman soldiers were a diverse bunch, recruited from all over. It has been estimated that in the early second century AD the whole of the Roman army, spread

Name	Latin Name	Construction Date (circa)	Units
Adel*	Burgodunum?	Late first century	
Aldborough*	Isurium Brigantum		
Bainbridge	Virosidum	90–105	Cohors VI Nerviorum
Brough	Petuaria	70	Praefectus Numeri supervenientium
Burghwallis		70–86	
Carkin Moor			
Castleford	Lagentium/ Legiolum	74	Cohors IV Gallorum, Cohors IV Breucorum
Catterick	Cataractonium	Late first century	
Cawthorn		77–83?	
Doncaster	Danum	70–80?	Equites Cirspiani?
Elslack	Oleanacum/ Rigodunum	70–80	Ala I Herculea
Hayton		70–80	
Healam Bridge		70–80	
Ilkley	Olicana/Verbeia	80	Cohors II Lingonum
Lease Rigg		77–83?	
Long Sandall*			
Malton	Derventio	77–83	
Newton Kyme		Late first century	
Roall		70–80?	
Roecliffe		70–80	
Rossington		Mid-first century	
Slack	Camulodunum?		Cohors IIII Breucorum
Staxton		70–80?	
Templeborough		43–68 (53–57)	Cohors IV Gallorum equitata
Thirkleby		First century	
Wensley		77–83?	
York	Eboracum	70–71	Legio IX Hispana, Legio VI Victrix

The forts of Roman Yorkshire and the dates of their earliest known construction. This includes only permanent structures and not the temporary camps. Names marked with * are a possible fort site and may also be represented by other settlement evidence.

cross the whole empire, included a total of 155,000 legionaries and 218,000 auxiliaries. The structures they garrisoned were also on differing scales. There was one legionary fortress in Yorkshire (in York) that could house the 5,000-plus soldiers in one place. The smaller forts spread throughout the region were controlled by the auxiliary soldiers in garrisons of approximately 500 men.

The military offered a good career path for many in the Roman Empire, though it often took them far from home. Many soldiers completed their terms of service and reaped the rewards as veterans of the army. From York we find the tombstones of Gaius Aeresius Saenus and Manlius Crescens, both veterans of the 6th Legion who evidently stayed in York after their release from military service. In Templeborough, Crotus son of Vindex had served with the Fourth Cohort of Gauls and was commemorated by his wife when he died aged forty (and presumably soon after his retirement). An auxiliary soldier, like Crotus, was given a metal diploma upon the completion of his service which acted as his mark of citizenship of the Roman Empire. In 2010, a fragment of one was found during excavations at Healam Bridge – its recipient's name is missing but he belonged to the Second Cohort of Gauls and was awarded his diploma in AD 140.

Brompton-by-Sawdon Military Diploma

A more complete diploma was discovered by a metal detectorist in Brompton-by-Sawdon in 2007. It comprises five surviving fragments of a copper alloy sheet. It originally had two leaves, both inscribed front and back and the surviving fragments are from the first leaf. The name of the dedicant is now lost, unfortunately, but we know that it belonged to an auxiliary soldier of the Cohors V Raetorum and that it was dedicated on 17 July 122. This soldier received his diploma of citizenship under Emperor Hadrian, who was present

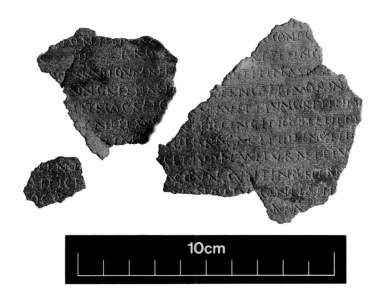

A military diploma awarded to an auxiliary soldier upon completion of his term of military service. Brompton-by-Sawdon, North Yorkshire, 2008. In the Yorkshire Museum (YORYM: 2007.171). (© York Museums Trust, CC BY SA 4.0)

in Britain in AD 122. It was during this time that the emperor ordered the construction of Hadrian's Wall. The veteran auxiliary here was probably part of an infantry-only cohort. Others were cavalry cohorts or a mix of both. The name of this cohort translates as the 5th Cohort of Raetians – people from Raetia. The province of Raetia is in modern central Europe and comprises parts of eastern Switzerland and southern Germany; though the unit had been in Britain for some time and may have bolstered its ranks with recruits from elsewhere. The diploma also records the name of the soldier's commanding officer – presumably the man who presented him with this diploma on his retirement – Sextus Cornelius Dexter. Sextus was in the middle classes and we subsequently hear of his successful military career from other inscriptions and his promotion to a procuratorship of the province of Asia.

Fremington Hagg Hoard

Military life wasn't always rough and utilitarian. Ceremonial armour and accessories were often high quality and made of precious materials. Found at some point prior to 1833, a hoard of horse-harness fittings was discovered at Fremington Hagg near Reeth, North Yorkshire. Parts of it were donated to the Yorkshire Museum and the British Museum. The objects in the hoard are all highly decorative, silvered harness pendants and mounts which originally adorned a horse bridle, reigns, and other straps. The hoard dates from the first century AD and, because of where it was found, it is possible that it is a stolen or looted collection of military objects from the invasion period.

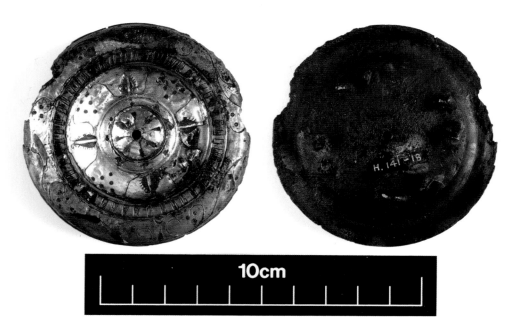

One of the pieces of horse-harness decoration from the Fremington Hagg hoard. Front and back faces shown. In the Yorkshire Museum (YORYM: H141.18). (© York Museums Trust)

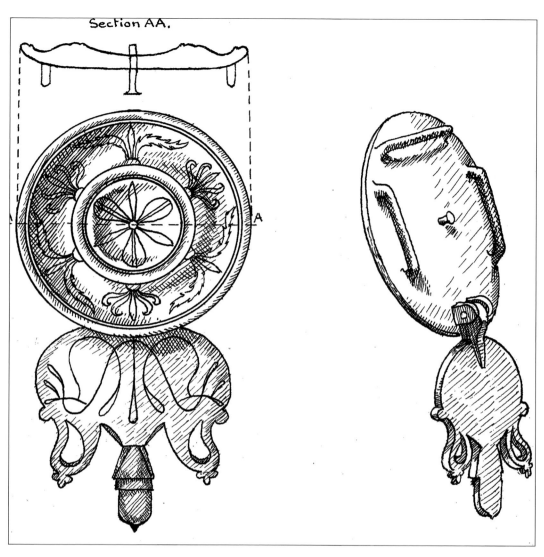

Section AA.

Drawing of fittings in the Fremington Hagg hoard, showing their connections and the reverse. From the archive of the Yorkshire Museum.

The Fortress at York

There is not time nor space here to go into fine details of all the differing military installations from Roman Yorkshire, but to present a sense of the differing scales let us look at case studies of a fortress, a fort, and a coastal signal station.

The first fortress of Eboracum was laid out in AD 70/71 by the retinue of military surveyors and engineers attached to the Legio IX Hispana (the 9th 'Spanish' Legion). The fortress was rectangular and can be accurately measured to a size of 1,600 × 1,360 *pes montalis*. A *pes* is a Roman foot, equivalent to 0.971 of an imperial British foot (or 29.6 cm). The *pes* was

17

an officially regulated measurement, based on a single ruler housed in the Temple of Juno Moneta in Rome. A right-angle was created through an application of Pythagoras' theorem and the careful geometric planning of a well organised and experienced surveying team in order to create the fortress shape. From these measurements a maximum size for the fortress enclosure wall of 473m × 402m can thus be calculated.

This was a monumental structure indeed. The first fortress was built of timber and had an earth and timber rampart surrounding it. The huge walls mainly surrounded a lot of barrack buildings for the 5,000 or so soldiers based there. The barrack spaces were simple structures with squat rectangular rooms designed to hold a *contuburnium* ('tent-group') of eight soldiers sleeping in bunks. The end block of each row was for the use of the centurion. The central zone of the fortress was its logistics and command hub, surrounded by the barracks on two sides, containing at least the *principia* (HQ building), the *praetorium* (the commander's house), *horrea* (granaries) and the *valetudinarium* (the hospital). At the rear of the *principia* was a *basilica*. This building was physically and metaphorically central to the fortress. The first stone *basilica* in the fortress dates from the late first/early second century AD and was a monumentally huge building for the period. It has been described as 'cathedral-like in scale', measuring 65.8 m in length and 22.6 m in width. This was probably the tallest building in the north of Roman Britain for a long time afterwards. By AD 108, in the reign of Emperor Trajan, the first timber fortress had started to be rebuilt in stone and shortly afterwards the garrison of the 9th Legion was replaced by the Legio VI Victrix

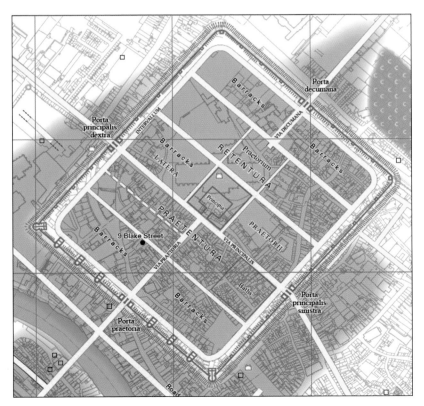

The legionary fortress at York. (Reproduced with permission from the *British Towns Atlas*, Volume V, ed. by Peter Addyman (Historic Towns Trust and York Archaeological Trust, 2015))

(6th 'Victorious' Legion). The fortress underwent a few tweaks in size and shape, including the addition of a series of bastion towers to the defensive curtain wall and buildings being repaired and altered. By the standards of other forts, the layout of York was not extensively modified.

The legionaries based in York were seconded to duties all over the region, including a large detachment of soldiers being used to build a significant portion of Hadrian's Wall in the AD 120s. As far as we known Eboracum was never directly attacked or raided during the AD 70s or any of the occasional periods of unrest in the ensuing centuries. A fortress like this was a monumental structure, but they weren't really designed to be fighting platforms – any military action that the 9th or 6th legions were involved in probably took place well outside of the city.

The fortress was graced by the presence of Emperors on several occasions. The Emperor Septimius Severus and his family lived in York from AD 208 to 211 while he was campaigning in the north and Constantine I was proclaimed emperor in York in AD 306 after the death in the city of his father, Constantius Chlorus. It became the capital of Britannia Inferior (covering most of northern England) when Britannia was split into two provinces in the early third century and became the civic as well as military capital in the north.

The city legally became a *colonia* and had a sizeable non-military and veteran community surrounding it (see Chapter 3). Eboracum was a large settlement in the region and despite its geographic location at the edge of empire, it became a place of international importance and intrigue.

That said, we actually know very little about the specific layout of much of the fortress. York has been continually occupied since AD 70 and this has left an important legacy in the archaeological deposits above those of the Roman period. The survival of many buildings from later periods of history, many of which are of national importance, has meant that the Roman stuff (stratigraphically deepest underground) isn't well excavated. It does mean, however, that it mostly remains safe. Let's now turn to a smaller military structure – a fort.

The Fort at Ilkley

Just like Eboracum beneath modern-day York, much of Ilkley Roman Fort is buried beneath the modern town. It was called either Olicana or Verbeia and was situated at an important point in the east–west road network. The timber fort was built in around AD 80 and abandoned *c.* AD 100 and measured approximately 98 m × 97 m. It was reoccupied in *c.* AD 169 and burned down in AD 196–97. It was rebuilt in stone by the end of the second century and reorganised and rebuilt in *c.* AD 300. This repeated pattern of occupation and abandonment, and destruction and rebuilding, was not unusual for a Roman fort in Britain. The provincial distribution of personnel was regularly modified in response to whatever evolving geopolitical situation the empire found itself in. As the table on page 14 demonstrates, there were a lot of forts established in Roman Yorkshire. With the exception of York, they were garrisoned by auxiliary units, and most of them were abandoned or rebuilt at least once during the period – no fort was constructed in the first century and remained standing unmodified for three centuries. Repairing and rebuilding a

fort was an important part of the work of soldiers in a garrison, as well as having security responsibilities for the roads and towns surrounding it.

An altar that was dedicated by Clodius Fronto, the prefect (commander) of the cohort in garrison at Ikley, gives us its name: Cohors II Lingonum 'the 2nd cohort of Lingones'. As mentioned, auxiliary cohorts were non-citizen soldiers raised in different parts of the empire. The Lingones were Gaulish, traditionally coming from what is now central France. There were undoubtedly other units garrisoned at Ilkley over its lifetime and we can't be sure exactly when the Lingones were there.

A small town grew up alongside the fort, the fortunes of which were tied to the occupation of the fort. The discovery of large stone tombstones of civilians highlights that this small community was relatively wealthy, as carved tombstones were expensive. One shows a woman seated in a large basket chair holding onto her plaited hair. The inscription beneath is fragmentary:

<div align="center">

DIS [M]ANIBUS

VED[]IC[. .]RICONIS FILIA

ANNORUM XXX C CORNOVIA

H S E

</div>

In translation this reads: 'To the shades of the departed. Ved[.]ic... daughter of ...riconis. Aged 30, tribeswoman of the Cornovii. She lies here.' The Cornovii are another native British tribe, showing the presence of internal migration among the native British population of Roman Britain.

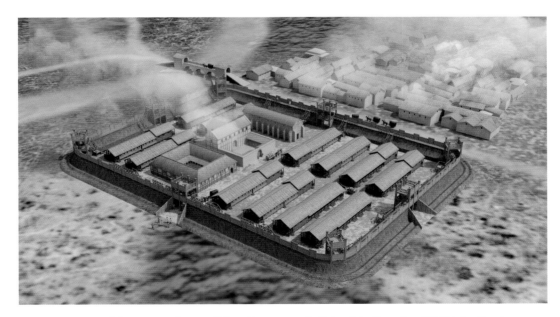

Reconstruction of the Roman fort at Ilkley. (Courtesy of Michael de Greasley, CC BY Attribution SA 3.0)

Yorkshire Coast Signal Stations

A series of late fourth-century Roman signal stations dotted the North Yorkshire coast. These were small installations – fortified towers – designed to keep a watchful eye over the North Sea and maritime traffic up and down the coast and to raise the alarm when necessary. Huntcliff, Goldsborough, Ravenscar, Scarborough, and Filey each had a signal station, and there is some evidence for a sixth at Whitby. These are the among the smallest of military structures from Roman Yorkshire.

The station at Scarborough is at the top of the cliff, on a promontory. The building was a wooden tower with stone foundations, rising several metres in height. The tower was used for observation as well as signalling. It was within a ditched enclosure 33 m in diameter. A small detachment (vexillation) could garrison the tower. It is now contained within the defensive walls of Scarborough Castle, showing the continued importance of this strategic position in later periods.

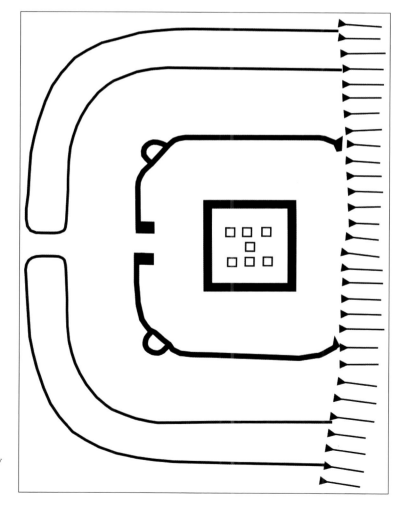

A plan of the signal station at Scarborough in the castle grounds. The maximum length is approximately 33 m. It shows the central tower, surrounded by an enclosure and a defensive ditch.

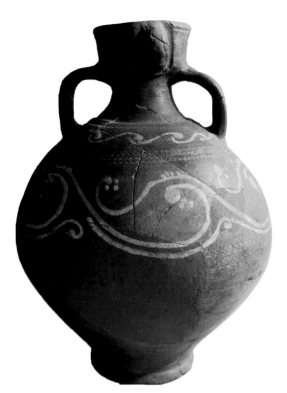

Left: A large earthenware flagon with a human face detailed on the neck from the signal station at Filey. It may have functioned as a cremation jar. In the Yorkshire Museum (YORYM: 2010.144). (© York Museums Trust, CC BY SA 4.0)

Below: Detail of the face.

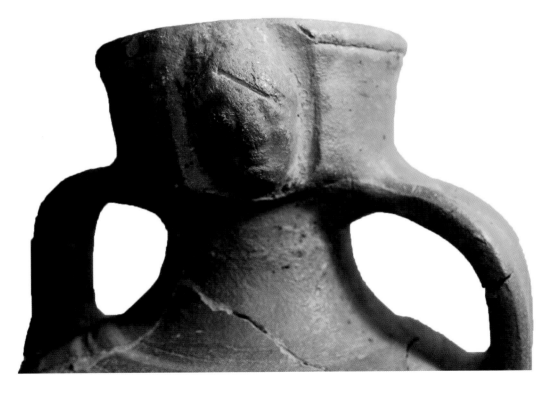

2

The Urban Centres

Having introduced the principal sorts of military structures that were an integral part of the foundation and flourishing of Roman Yorkshire, let us investigate some of the other important urban centres. I hesitate to describe them as 'civilian' places as most of the towns of Roman Yorkshire were geographically connected to a military structure. However, it is in these places that civilian populations lived alongside the military and military families (both legal and unofficial ones). The distribution of these urban places in Yorkshire is biased to what is now North Yorkshire.

York

A non-military encampment associated with the fortress probably grew up quite quickly after the 9th Legion started construction at York. Initially this group might have comprised traders selling to the army, family members, and other hangers-on. The fortress was, architecturally, a very ordered space, but the civilian settlement was much more organic and has differently aligned and sized buildings, shops, and warehouses all centred on the main north–south road leading to the town. The areas outside of the fortress of York probably grew to house a larger population than the fort itself and this community was bolstered by its relationship to the Roman army. When a legionary retired, he was offered a land grant or a pot of cash as his pension – in the early third century York gained the rank of *colonia* as a reflection of the presence of veterans in its community.

The '*colonia*' status, literally translating as 'colony', was a somewhat archaic term to be applied to the Roman settlement at York by the time it was given. It was a mark of status with its roots in the earlier days of the Roman Republic (fifth to first centuries BC), where groups of citizens or military veterans formally colonised areas in the Mediterranean as part of the empire's expansion. *Colonia* was an important honorific rank within the Roman Empire and only four other towns in Britain were granted the status – Colchester, Gloucester, Lincoln and London. The earliest dateable inscription that names Eboracum as a colony is AD 237 and comes from Bordeaux – from an altar given in thanks for a safe sea crossing from its patron and York resident, the priest Marcus Aurelius Lunaris.

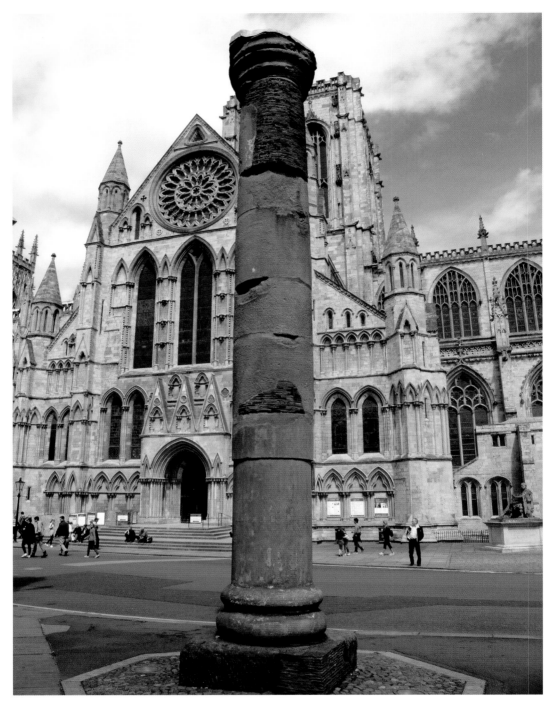

This column once stood in the *principia*, the headquarters building in the very centre of Eboracum (York Minster, in the background, is directly above it). It was a huge, monumental building and one of the tallest buildings in Yorkshire for centuries to follow. (Courtesy of Carole Raddato, CC BY SA 2.0)

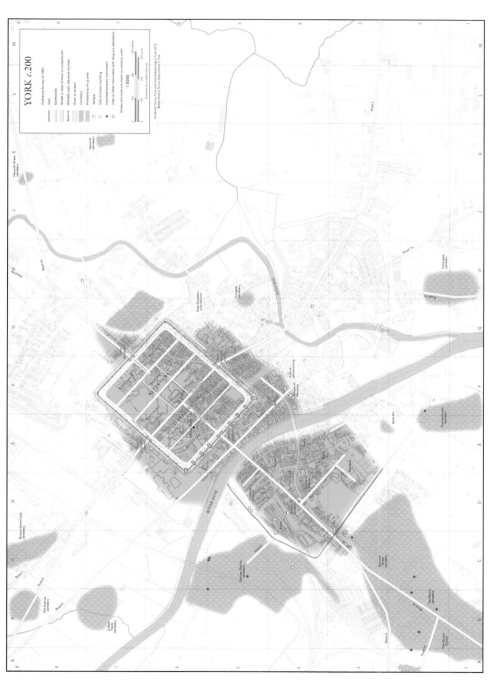

Roman York at the turn of the third century AD. The legionary fortress is central in this map. Note the roads spanning off in all directions and the large settlement on the south side of the river. Brown shading represents the known built-up areas. Green shading represents cemeteries. (Reproduced with permission from the *British Towns Atlas*, Volume V, ed. By Peter Addyman (Historic Towns Trust and York Archaeological Trust, 2015))

York was undoubtedly the largest population centre in Roman Yorkshire and probably housed several thousand people as well as, at certain times, the five or six thousand legionaries in its accompanying fortress. Occasionally large parts of the garrison left on military campaigns in the north and, notably, to construct a large section of Hadrian's Wall. Let's focus on the non-military parts of the city though. If you were able to walk through the gateway into the *colonia* from the south, near to where modern-day Micklegate Bar is, you would be met with a busy urban town. The road slopes down from this point and would have been bordered by the narrow fronts of elongated houses and filled with temporary market stalls and traders carrying their wares. It would be busy and loud most of the time. Sounds from the nearby forum pinpointed the market hub of the city. The large bathhouse to the left of this road threw up smoke from its great chimneys and some of the fancy houses of the richer residents took up space on the right. In order to get to the wall and the city gate in the first place, a traveller had to follow the long line of the road heading towards the city, which was lined by the gravestones, tombs, and mausoleums spread out in great numbers on both sides. There was a large river here and a wooden bridge to cross to the north side where the wharves and warehouses stood. Small boats travelled upstream and downstream, with the occasional larger vessel making port after travelling from the Continent or upriver from Brough. York was a cosmopolitan place, with an intermingling of people, cults, and fashions from all parts of the empire as well as the native British. The following three case studies serve to demonstrate this through highlighting an architecturally important building, an archaeologically important grave, and a historically important individual.

York's Bathhouse

There were several bathhouses in Roman York. Some private households may have had them (the legionary legate's house certainly did) and there was a large one within the fortress for use by the garrison. This military bath is preserved beneath the modern city and parts of it can be seen beneath the aptly named Roman Bath pub on St Sampson's Square. The bathhouse on the south side of the river, known as the 'public baths', was a monumental building in Roman York and undoubtedly held an important role in providing hygiene facilities and relaxation and pleasure. A large bathhouse was a community space. The bathhouse was located immediately inside the western edge of the medieval wall in this part of the city. It was partly excavated twice; initially in 1839–40, during excavations for York's first railway station, and then again in 1939 during excavations for a bomb shelter during the Second World War. This piecemeal approach has meant that we do not have a complete plan for the baths and its associated buildings and that we remain uncertain as to whether they were all contemporary with each other.

Roman bathhouses incorporated several different rooms with different functions and bathing wasn't necessarily a quick process. Most contained an *apodyterium*, the changing room where spaces were available to store clothes. Sometimes baths included a *gymnasium* for bathers to work out in before or during their bath. Patrons then passed into the

tepidarium (warm room) and then into a *caldarium* (hot room). In these rooms, bathers washed with oil and scraped it off with a tool called a *strigil*. Drinks and snacks could often be purchased, and some baths had gaming boards built into their long seats so bathers could play board games. Massages could be available from enslaved people owned by the bathhouse. After warming up and cleansing, the final step was to use the *frigidarium* (cold room), which included a cold plunge pool. At the public bath in York there was clearly four or five rooms joined together and supplied by lead water pipes. Nearby is a large *caldarium* – one of the largest in Britain.

Bathers could bring along their own oils and lotions as part of the bathing process, in jars and bottles. One of the most interesting examples of this sort of container is the metal top of a *balsamarium* in the shape of an infant from a grave beneath the railway station. It would have sat on top of a wide bottle or jar and been suspended by the two lugs on top of its head. A small flap opened to allow the lotion to be poured or scooped out from within. It is one of only five surviving examples of this sort of object from Roman Britain.

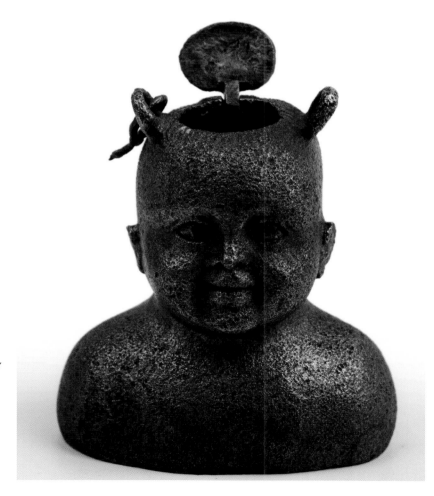

A copper alloy *balsamarium* depicting an infant. In the Yorkshire Museum (YORYM: H2407). (CC BY SA 4.0)

The Ivory Bangle Lady

Perhaps the most well-studied individual biography of a resident of ancient Eboracum is a woman who died in the late third or fourth century AD and was buried in a coffin in Sycamore Terrace, to the west of the fortress and following the road in this direction. She is affectionately known as the 'Ivory Bangle Lady' because of the presence of a bangle of African elephant ivory on each of her wrists, paired with a Whitby jet bangle. This is a rare and exotic material worn alongside the regionally fashionable one. She also wore a silver *bulla* necklace, a pair of amber-coloured glass earrings, and a glass bead necklace when she was buried. A blue glass jug, a glass mirror, and an inscription plaque were also present.

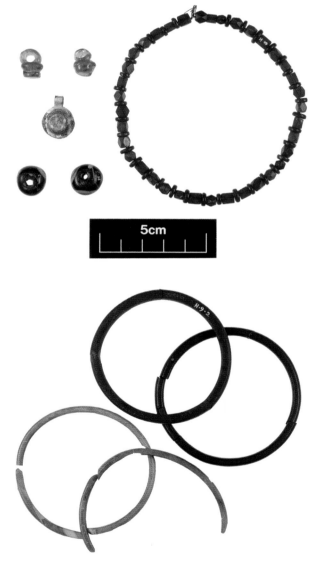

Exotic jewellery, including an ivory and a jet bracelet on each wrist, worn by the Ivory Bangle Lady. Sycamore Terrace, York, 1901. In the Yorkshire Museum (YORYM : H2407). (©York Museums Trust, CC BY SA 4.0)

Scientific analysis of her teeth (looking at stable radioactive isotopes) tells us an interesting story: she spent her childhood somewhere with a hot and arid climate and then moved to Britain. Her isotopic signature changes dramatically from the far edges of empire to local. She has some features of someone of mixed ancestry and we suspect she came to York from North Africa. She died in her early twenties. It is fascinating to find that her own personal story – as a migrant from Africa to Yorkshire – was also reflected in the jewellery she wore on her wrists. Other research has highlighted the presence of people from all over the Roman Empire in Britain.

Constantine the Great in York

Eboracum was the temporary home to several Roman emperors – testament to its civic and military position as an important place in the north of Britannia. It was, in the early third century, made into the provincial capital of a new province (Britannia Inferior) when Britannia was split into two and again, in AD 296, it became the capital of another new province (Britannia Secunda) when the island was split once more. Britain was split at a time when the whole Roman Empire was also divided. During this period (known as the Tetrarchy) the empire was split into East and West empires with a senior emperor ('Augustus') each with a junior emperor ('Caesar'). Constantius

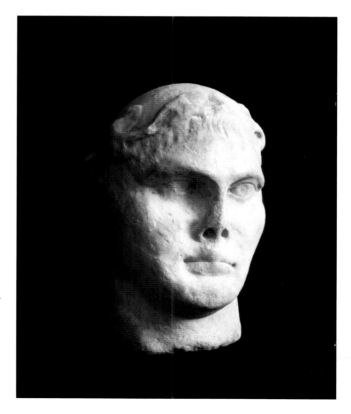

Only the head from the twice life-sized marble statue of Constantine the Great survives. The original statue was a significant monument in Roman York. From Stonegate, York, sometime before 1823. In the Yorkshire Museum (YORYM: 1992.23). (© York Museums Trust, CC BY SA 4.0)

29

Chlorus, the father of Constantine the Great, was elevated from his position as Caesar in the West to Augustus on 1 May 305 when the ruling Augusti (Maximian and Diocletian) abdicated. Constantine (the son) was in the court of Galerius (Constantius' co-emperor in the East). It was a politically complicated time. Constantine was snubbed in becoming a junior emperor and returned to his father's court in 305 in time to join a military expedition to Britain. After campaigns in Scotland, the imperial family in the West overwintered at Eboracum. Constantius fell ill and died in York in July 306. On his deathbed, Constantius recommended that his son Constantine, who had no explicit right to rule, succeed him instead of his appointed junior emperor. This worked, and Constantine was hailed as emperor in York. It's not the place here to continue his fascinating biography, but this act started a civil war that Constantine eventually won. The importance of his accession in York is that the world changed on that day. Constantine eventually became sole emperor and continued a dynasty that started with his father and passed through his children and son-in-law until AD 363 and then beyond in the Valentinian dynasty. Constantine's role in Western European history looms large, through his relaxation of persecutions against Christians and numerous military campaigns throughout the Roman Empire. Few places can boast that they made an emperor, but Yorkshire certainly can.

Aldborough

The town of Aldborough may have grown out of an abandoned first century fort, but this is not certain. Its Latin name, Isurium Brigantum, highlights its place in the native territory of the Brigantes. Isurium had its roots in the early to mid-AD 70s, and so was more or less contemporary with York. The town isn't extensively excavated, but we do know about a central forum next to St Andrew's Church and some other municipal buildings. The town walls date to c. AD 150–160. The extent of these walls, enclosing an area that is over 600 m × 400 m, shows that there is a lot of Isurium that we do not know about. Recent fieldwalking and geophysical survey around the site has added a lot of colour to this picture, identifying numerous additional buildings, many of which were probably houses, and helping to tie down the dates at which the town changed.

It is particularly famous for its mosaics, two of which remain in situ at the site. The first, found in 1832, depicts a lion sitting underneath a tree and is surrounded by geometric designs. The second, features a prominent eight-pointed star at the centre surrounded, alternately, by monochrome geometric designs and colourful interlaced patterns. Probably the most famous mosaic from Aldborough, though, is on display in the Leeds City Museum; it depicts the she-wolf and the twins Romulus and Remus from the foundation myth of Rome. The vast majority of Romano-British floors were not decorated with mosaics as they were expensive, painstaking creations by specialist craftspeople. Commissioning a mosaic required sufficient money to afford it and enough rooms in the house to work with. Single- or two-roomed houses and flats were rather common in the urban parts of the Roman Empire and these big houses with mosaics were the preserve of the rich. Roman Aldborough evidently had a lot going for itself.

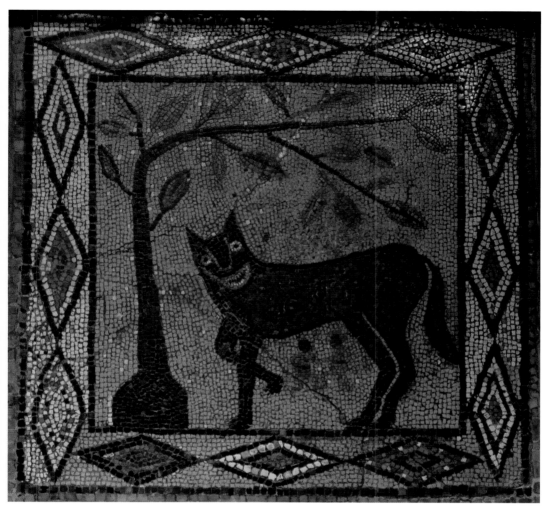

The famous mosaic depicting the she-wolf and twins from Aldborough. In Leeds City Museum. (Courtesy of Following Hadrian)

Brough

Brough, sited on the north side of the River Humber, was an altogether different sort of site to Aldborough or York. It was founded as a fort in AD 70 and transitioned into a town with much larger enclosed walls, probably in the second century. A number of houses have been discovered, many of which were timber (or timber with stone foundations) but the presence of wall plaster and ceramic roof tiles speaks of different types of buildings, in stone and timber, also being used in the town. A corn drier found outside of the eastern defences is important evidence for agricultural activity in the countryside surrounding the town. These eastern defences are themselves unusual, comprising a triple bank and ditch.

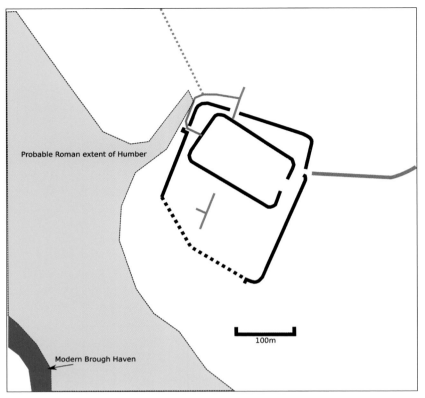

Probable Roman extent of Humber

100m

Modern Brough Haven

Left: Map of the town defences of Brough. It was located at an important position on the north side of the River Humber.

Below: Nothing to see here. The Burr's playing field in Brough lays on top of a significant portion of the Roman settlement.

Looking south over the River Humber from the modern Brough Haven. River crossings here had to contend with the tidal current, shifting sandbanks, and the frequently strong off-shore winds.

The location of any traditional 'urban' public buildings, like the bathhouse or forum are uncertain.

While we clearly are underappreciating the physical extent of Roman Brough, it held an important role in this part of Yorkshire. The discovery of several lead pigs, highlighting its economic activity, and the important dedication by the *aedile* Marcus Ulpius Januarius, highlighting its civic position, are testament to this. Its position on the river was unusual for a town in the north of Britannia and allowed access to the Humber and the North Sea; Brough was probably a lot more cosmopolitan than we give it credit for. Travel by boat was a lot quicker than by land, and Brough probably had many soldiers, traders, and travellers passing through.

Malton

The urban areas outside of the fort at Malton are archaeologically well understood. This settlement which grew up alongside a fort is called a *vicus*. While the forts at Ilkley, Castleford, and Doncaster all have evidence of these as well, they are not as well understood. The settlement at Malton surrounded the south-eastern side of the fort, between it and the River Derwent. In its layout, the *vicus* was like a rural roadside

settlement with elongated strip buildings facing one of two roads. There was also a large settlement on the other side of the river, in modern Norton, which was a centre for local pottery and metalwork production. Its position between the coast and the big regional settlement at York also led to it having an important role in the transport and working of Whitby jet.

Commemorative marker at Orchard Fields, Malton, recording the position of the north corner of the fort.

3

Rural Yorkshire

The large and small towns and the forts constituted the urban areas of Roman Yorkshire, but these were numerically quite rare when compared to the larger numbers of small rural settlements surrounding them. The reality of life for most people was of small rural farmsteads. The farmsteads, small unenclosed villages, and villa sites spread throughout the landscape were much more common than the towns and forts. The Roman Rural Settlement project recorded evidence for over 170 farms from Roman Yorkshire, some of which were large farm complexes with many buildings.

Often these rural settlements were villages and hamlets, sometimes physically connected to the main roads of Roman Yorkshire. Many of them were on, in, or near to earlier Roman or Iron Age settlements. These places in the landscape were productive enough to support communities dotted all over. As long as there was access to fresh water and a way to make a living people could live there for generations. Some of the largest areas of agricultural land were centred around a villa. A villa was just that – the building (or group of buildings) that formed the centre of an agricultural estate. More than twenty Roman villas are known from Yorkshire and they could have owned the lands or fields around them for miles. The domestic parts of villas were often richly decorated spaces, highlighting the wealth-producing capabilities of this arrangement.

Roman influence in the countryside. The remains of the defensive structure of the fort at Bainbridge is visible in the image, but the wider countryside surrounding it and other forts was filled with roads, farms, small settlements, and villas. (Courtesy of George Hattin, CC BY SA 2.0)

The farmsteads don't leave big archaeological footprints like forts and towns. They are often identified by scatters of pottery at the surface of fields or by cropmarks visible on aerial photography. These sites have rarely been thoroughly investigated and most are entirely unexcavated. Our archaeological focus is often on the urban areas because towns and settlements may have continued in use for hundreds of years after the Romans, even up to the present day. Redevelopment and building in these towns inevitably led to the discovery of Roman remains beneath them, whereas many parts of the Yorkshire countryside have been used for agricultural purposes for centuries, leaving a lot of archaeological remains hidden.

Dalton Parlours Villa

The Roman villa at Dalton Parlous is the only known villa site from West Yorkshire. It was first discovered in 1854 but only formally excavated to a modern standard in the 1970s. The villa was founded at the turn of the third century AD and was built over part of an earlier Iron Age settlement on this site. The main villa building was a long structure measuring 30 m × 16.5 m. It had hypocausts (underfloor heating) in some of its rooms, elaborately painted walls, and a large mosaic floor. Other buildings in the villa complex included a separate bathhouse, another aisled building which included a kiln and an oven, and several smaller rectangular structures, which were probably used for malting or drying crops prior to milling. Some of the materials must have been purchased from York as many of the tiles were stamped with the insignia of the 6th Legion, who controlled the production of these materials in York itself. The villa and the farm remained in use in until AD 370, when it was abandoned. At this time the well was filled in so it couldn't be reused, though this may have been a ritual 'ending' to relate to the abandonment of the site.

A large floor mosaic was discovered in the nineteenth century. It is a semicircular apse shape and may have been at one end of a larger rectangular mosaic and probably followed the curving line of the room it lay in. In the centre is a depiction of the Medusa – the figure in the classical myth with snakes in her hair and a gaze that could turn people to stone. In the myth she was beheaded by the Greek hero Perseus. The goddess Athena aided Perseus by giving him the mirrored shield he used to defeat Medusa; he repaid this gift by giving the still living head of Medusa to Athena. Athena placed the head of Medusa on her shield – she was often depicted holding this Medusa- shield in Greek and Roman imagery. It was a popular myth to be depicted in mosaics, often in the centre of them. Another example is present in the centre of one mosaic from a house in York. The image probably performed a sort of protective function: her powerful gaze could ward off evil. She is bordered on the panels by interlaced bands made from different coloured *tesserae* (the small square blocks that make up the shapes in a mosaic) and this is surrounded on the outside edge by a repeated floral pattern. Above her head (at least, on the image) is a *krater*, a sort of large Greek drinking vessel. It shows the reach of Roman artistic traditions (and its classical antecedents) for a myth that was centuries old and based in the central Mediterranean to be prominently displayed on this late Roman villa in West Yorkshire. We often look at mosaics on walls in museums, but we must remember that they were floors designed to be walked on and be covered by furniture, rugs, and plants.

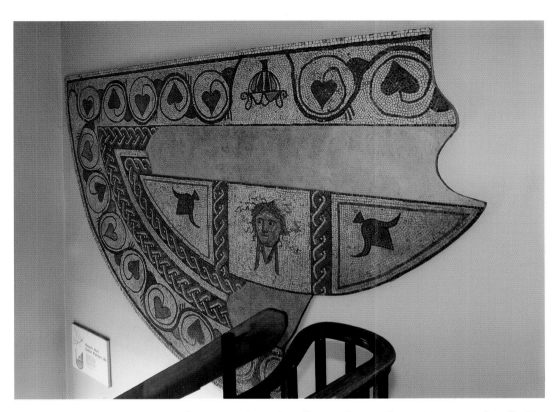

Part of the large, semicircular mosaic from the villa at Dalton Parlours. Museums often find it easier to display them on walls, though this would seem rather unusual to a Roman viewer. In the Yorkshire Museum (YORYM: 1973.64). (© York Museums Trust, CC BY SA 4.0)

Road Network

An extensive road network grew up through the countryside to connect the early forts and towns of Roman Britain. Many Roman roads followed the lines of much older trackways and routes through the landscape. The major difference from the earlier routes was the more industrial construction of these roads in stone. The basic construction of a major Roman road used a compacted layer of sand and gravel on top of hardcore or layered stones. The finely finished stone road surfaces of popular imagination were rare in the Roman provinces (though they did exist in Rome) and were largely unnecessary in Britain. Roads were hardy structures but required maintenance from time to time. To quote Mike Bishop's *The Secret History of the Roman Roads of Britain:* 'The greatest enemies of a Roman road were probably the weather (with frost damage a major problem) and the encroachment of vegetation.'

There were numerous Roman roads throughout Yorkshire, primarily criss-crossing north to south or east to west. Forts and larger settlements were joined by these major routes, though the forts were usually linked to them by a short branch road. Roman roads in Britain were given numerical values by Ivan Margary in his 1955 volume on the subject and these numbers are used in parentheses here.

From York, the main road north (8) is known by its medieval name – Dere Street. This passed through Aldborough, Healam Bridge, Catterick, and Scotch corner onto Piercebridge. From Piercebridge it passed through several other forts before reaching Corbridge. The road east from York (810) probably went to Bridlington via Stamford Bridge with a branch (81) heading north towards Malton. The routes of other roads in this area are less certain. From Stamford Bridge, one of the main trunk roads south (2e) curved south and east through Hayton, Shiptonthorpe to Brough where there was a river crossing over the Humber into Lincolnshire. The other main trunk road south (28) left York from the south-west and headed to Tadcaster before turning south towards Castleford and Doncaster. 28 eventually reaches the

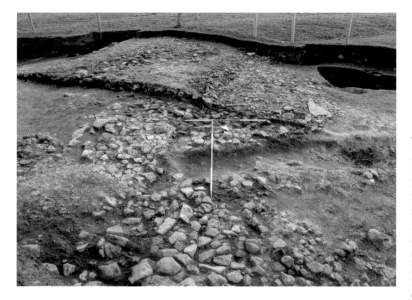

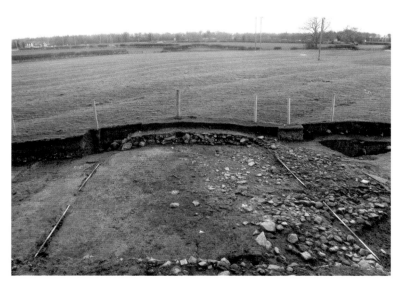

Two views of the Roman road of Dere Street at Scotch Corner. The road was relaid several times. The left image shows a change in the alignment with the later road built on top of the earlier one. The right image is taken from on top of the road, showing its size, with the ranging rods marking the edges of the roadside ditches. (© Northern Archaeological Associates, used with permission)

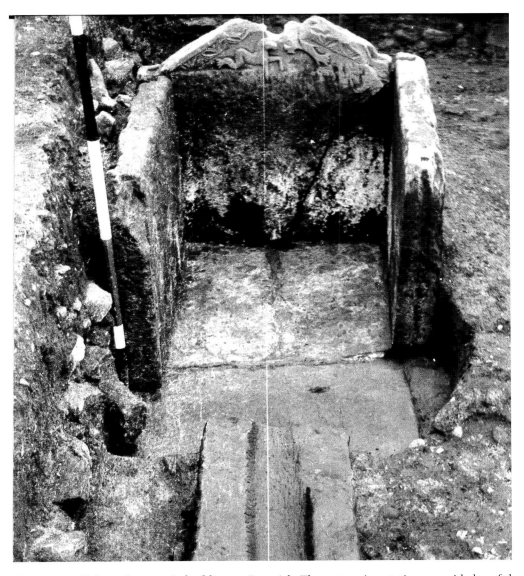

The stone well from the mansio building at Catterick. These stopping stations provided useful amenities, like stabling, beds, food, drink, and some hygiene facilities. (From the archive of the Yorkshire Museum)

colonia at Lincoln. Tadcaster was situated at an important crossroads, with the links on road 28 to York and Castleford, but it also had a road due north that joined up with Dere Street (and avoided a diversion through York) and one west (72) that passed through Newton Kyme, Adel, and Ilkley towards the forts and settlements at Elslack and then Ribchester. A road from Ilkley (720) headed north-east directly to Aldborough. These roads used the landscape to their advantage. It should come as no surprise that many of these routes are also taken by the modern road system throughout the region and, in some cases, are directly beneath them.

Castleford Milestone

A mile marker found before 1861 near Castleford was sold to the Yorkshire Museum in 1915. The distance it was marking is now lost but the stone reads:

IMP CAE[S]
MAR ANNIO
FLORIOANO
P F AVG

For the Emperor Caesar Marcus Annius Florianus Pius Felix Augustus.

This is simply the name of the Emperor Florianus, who had a brief reign in AD 276. Handily, this allows us to date this stone quite closely. Florianus seems to have ordered a series of these markers to be built, or to have ordered the rebuilding or repairs of roads, during his brief reign. Other examples with very similar inscriptions have been found at Ackworth on the Roman road between Doncaster and Tadcaster, and near Bowes. The road network across Yorkshire was waymarked with stones like these identifying the distance to the next town or fort. If this milestone was erected as part of a series of repairs to the road, this tells us that the condition of these roads was not always favourable.

Terrington Bronzes

In many of the rural areas of Yorkshire, Roman settlements may have been abandoned and then never, or only briefly, reused up until relatively recently. Occasionally, these rural sites are archaeologically excavated, but it is the accessibility and growth of metal detecting as a hobby in England that has allowed us to develop our understanding of

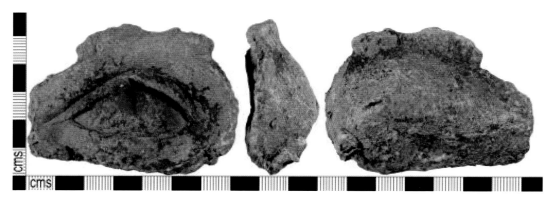

An eye from a once magnificent bronze statue. It was found near Terrington (PAS: YORYM-F46085). (© York Museums Trust, CC BY SA 4.0)

Roman Yorkshire beyond most urban spaces. The Portable Antiquities Scheme records archaeological finds made by members of the public and they primarily work with metal detectorists to fill in these gaps in our knowledge. As an excellent example: over recent years, more and more fragments of a large bronze statue have been discovered in an arable field near Terrington in Ryedale. The fragments probably once belonged to a grand statue of an emperor – the bright bronze metal used to highlight his unearthly splendour. We know that most ancient statues would have been painted or set with gemstones, and draped with real clothes and flowers and other trinkets. Large statues like this were probably more common in Britain than we give credit for, but the fastidious recycling of metal (especially copper alloys) has probably resulted in there being fewer fragments left for us to find.

The statue may have been in a private villa somewhere, or on the side of a road or near to a *mansio* (a sort of carriage stop). It probably hadn't moved far away from its original site and without metal detectorists looking in the modern rural landscape we wouldn't have known about this statue from the ancient rural one.

4

Dis Manibus

The proper treatment of the dead was an important part of Roman culture and was an aspect of life that was governed by various secular and religious laws. The most important of which was that graves were placed outside of the sacred boundary (*pomerium*) of a town or city. For modern archaeologists it can be relatively straightforward to identify the edge of a settlement and the location of the cemeteries. As many of the towns, villages, and villas of Roman Yorkshire were in sustained or periodic use for decades and centuries, many cemeteries grew to be very large.

Speaking very generally, in the first two centuries AD a pagan funeral in the Roman Empire was more likely to take the form of a cremation whereas in the third and fourth centuries it was more likely to be an inhumation (burial of the body in the ground). Cremated remains were also buried in the ground, but the main difference is in how the body was being treated before this. There are, of course, numerous exceptions to this very loose rule and there appears to be a tradition of cremations continuing in northern Britain long after it became unfashionable elsewhere.

A traditional pagan funeral started at home, with a procession of the mourners to the site of the grave. The body of the deceased would have been cleaned and usually dressed in finery, with jewellery often worn. Plants, flowers, and perfumes could be placed onto the body while it was moved to the cemetery. Once in place, the deceased was either burned on the funeral pyre or buried at the site of the grave. Objects placed onto a pyre obviously burned away or melted, but sometimes objects were added to the ashes before their burial. The objects in an inhumation burial often survive along with the remains and can be important clues to the date of the grave, as well as the social status, religious beliefs, and sometimes the ethnicity of their owner.

'To the shades of the departed', or '*Dis Manibus*', adorns the start of hundreds of Roman tombstones in Britain. It was usually abbreviated to the letters 'DM', but it always marked the start of a funerary epitaph on a gravestone. Comparatively few graves were marked by an inscribed tombstone, and of those even fewer included a sculptural carving as well. Where these elements come together, we can find out a lot of biographical information about the deceased, even without the survival of the grave.

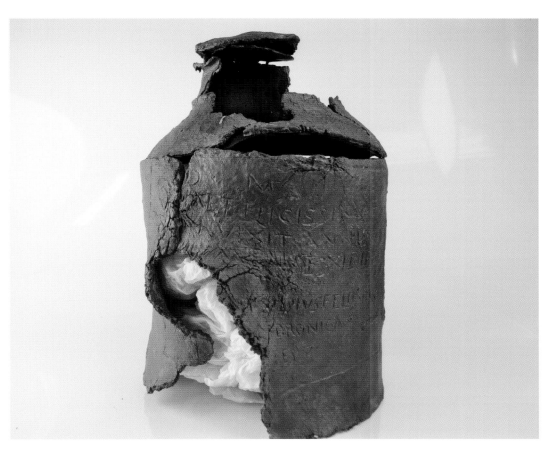

The phrase *Dis Manibus* can be found on all sorts of monuments and funerary containers. This large cremation urn in lead has an inscription on one side starting 'D M'. The rest of the inscription commemorates Ulpia Felicissima, who died aged twenty-three and is remembered by her parents, Ulpius Felix and Andronica. From York railway station, 1875. In the Yorkshire Museum (YORYM: 2015.390). (© York Museums Trust)

The Necropolis at York

Undoubtedly the biggest cemetery from Yorkshire is associated with its largest settlement at York. The city was continuously inhabited from AD 70 until the early fifth century AD so thousands of people probably died there, and hundreds of Roman graves have been located.

There are several small cemeteries to the north, west, and south-east of the city. Each follows the line of the roads, so they were easily accessible to mourners. One cemetery though was huge (see the map of the city in Chapter 3; the area in question is the large area of green shading in the lower left corner). It filled the immediate landscape from the area around the southern gate of the settlement (near Micklegate Bar) down to near the riverside and continued up the hill to The Mount and through parts of Heworth. We may also count the graves lining the road heading south out of the city, modern Blossom Street, as part of this cemetery.

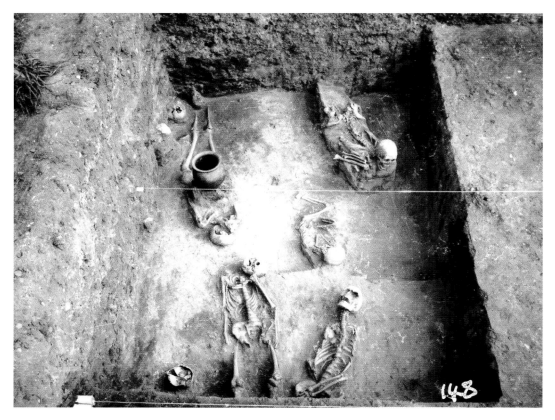

The Roman cemetery at Trentholme Drive, York. It was excavated in the mid-twentieth century by L. P. Wenham. Modern excavations work in a different way, but this photograph is helpful in showing the close proximity of Roman burials and some of the many grave goods that often accompanied them.

A significant amount of our information about Roman York comes from this necropolis. It was cleared as part of the construction of the Victorian railway station in York in the 1870s and the accompanying tracks that spread out to either side of it. Within the cemetery, graves abutted up against each other and in some cases were cut into earlier ones. The late Victorian archaeological methodology didn't record exactly where some burials were found and often didn't retain the skeletal remains of some graves – there are many examples of which only the skulls were kept as part of the record. What was especially well recorded though, were the sculptural and inscribed monuments. The numerous tombstones and sarcophagi from this cemetery are nationally and internationally important objects.

Funerary Relationships

Inscribed epitaphs are really valuable in helping us to identify the familial or professional relationships of the deceased. It was a common practice for whoever commissioned the tombstone to have their name inscribed upon it, in honour of their relationship to the

deceased, and to mark out that this important (if unwanted) duty had been fulfilled. By looking at the numerous inscriptions at York we can find evidence of these personal relationships. Note that their often-fragmentary nature means that we don't have all of the original information. Aurelius Superus was a centurion who died aged thirty-eight and was commemorated by his wife Aurelia Censorina, and Vitellia Procula commissioned the tombstone for her teenage daughter. Valerius Theodorianus' tomb was set up by his mother Emilia Theodora. Hyllus was dedicated to as a 'foster-child'. Occasionally tragedy hit multiple members of a family together and so young children were included on dedications to their parents: Sepronius Martinus set up the tombstone of Julia Brica and their daughter Sepronia Martina, and Antoninus Stephanus commemorated his thirty-year-old wife Eglecta and their three-year-old son Crescens together. Sometimes the inheritors ('heirs') of the deceased dedicated the tomb. In these cases, the dedicant probably had no surviving children and adopted an heir, sometimes a family relation or professional acquaintance. Gaius, son of Gaius (a fine Roman tradition of naming children after their parents), was a soldier of the 9th Legion and was commemorated by his heirs and his freed slaves as inheritors of his estate. It was unusual for young infants to be individually commemorated in this way, so the rather poetic inscription on the sarcophagus of Simplicia Florentina is particularly moving:

DM SIMPLICIAE FLORENTINE
ANIME INNOCENTISSIME
QVE VIXIT MENSES DECEM
FELICIVS SIMPLEX PATER FECIT
LEG VI V

To the shades of the departed [and] of Simplicia Florentina, a most innocent soul, who lived ten months; her father, Felicius Simplex, made this: centurion of the 6th Victorious Legion.

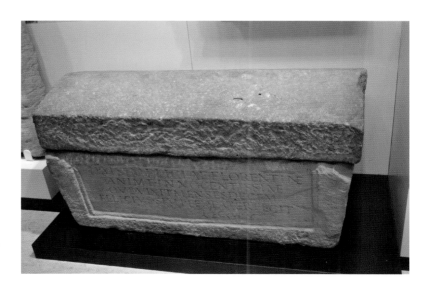

A tragic insight into the loss of a young life is recorded on this sarcophagus to Simplicia Florentina, dedicated by her grieving father. From the Mount, York. In the Yorkshire Museum (YORYM: 2003.4). (© York Museums Trust, CC BY SA 4.0)

45

People and Places

While they don't give us the whole picture, funerary inscriptions are incredible snapshots of individual biographies. The information they can provide about the people who lived in Roman Yorkshire is often unparalleled. As a case study, let's first consider three tombstones from Templeborough, all discovered in 1916–17 and now in Clifton Park Museum.

DIS M CINTVSM
VS M COH IIII GALL
ORVM PO MELISVS

To the shades of the departed: Cintusmus, soldier of the Fourth Cohort of Gauls;
Melisus set this up.

As it was a fort site, it is not hugely surprising to find a soldier commemorated. Cintusmus is recorded as a soldier serving with the garrison at Templeborough. We don't know who Melisus was, but he has paid for the expense of a funerary epitaph. As is usual on Latin tombstones in Britain, most of the words are abbreviated to commonly understood formulae: Dis M (or just D M) for *Dis manibus*, M for *miles* (soldier), COH for *cohortis* (cohort), etc. There are numerous different abbreviations visible on the tombstones used throughout this book. Also note the format of using IIII instead of IV for the number four. Modern viewers might find this an unusual way of displaying a Roman numeral, but this was an equally accurate and correct way of presenting it (as four ones (IIII) instead of five minus one (IV)).

DIS MANIBVS CROTO VINDICIS EM
ERITO COH IIII GALLORVM ANNORVM
XXXX MONUMENTVM FECIT FLAVIA PE
REGRINA CONIVNX PIENTISSIMA MARITO PIENTISS
IMO TITVLVM POSVIT

To the spirits of the departed and to Crotus, son of Vindex, *emeritus* of the fourth
cohort of Gauls, aged 40; Flavia Peregrina, his devoted wife, made this monument
and set it up this inscription to her devoted husband.

This tombstone is a much more personal example, clearly dedicated by a grieving Flavia to her dead husband. Crotus is described as an *emeritus*, this means he had served his full term of service and had been discharged from the army. Crotus and his wife were still living in or near Templeborough after he was discharged, though his age of death suggest that he had not been out of the army for very long at all. Studies have shown both that many tombstones estimate the ages of their dedicants (rounding up or down to the nearest five or zero) because some people simply couldn't be sure, and also that teenagers could be recruited. If Crotus served his full term he might have been fourteen or fifteen when he signed up.

DIS M
VERECVD RVFI LIA CIVES
DOBVNNA ANNOR XXXV EXCINGVS
CONIVX CONIVGI KARISSIMA[E]
POSIT DE SVO

To the shades of the departed: Verecunda daughter of Rufus, a tribeswoman of the Dobunni, aged 35; Excingus, her husband, from his own resources set this up to his beloved wife.

This time the tombstone is of a woman, Verecunda, and is dedicated by her husband. The age recorded is another tragically young death. It is certainly interesting that Verecunda is named as a member of the Dobunni. She was, therefore, a native Briton. The Dobunni were a British tribe centred around Worcestershire and Gloucestershire with a probable capital at Cirencester. This doesn't mean that Excingus was a Roman man marrying a native British woman, we have no idea of his ancestry from this tombstone, nor can we be clear how long after the invasion period that people retained a tribal identity. Perhaps they both were from the Dobunni? After all it was the husband that dedicated the stone and dictated the information to the stonemason to carve and he may have wished to show his own tribal allegiance in writing as well as his wife's. Nonetheless, it is a great example of internal migration in Roman Britain.

Bainesse Cemetery

A recent Roman cemetery excavation took place at Bainesse as part of the widening scheme of the A1(M) road near Catterick. Between 2013 and 2017 archaeologists located part of the cemetery, from which 232 grave features were recorded. Of these, 121 still contained skeletal remains and seventeen contained cremations. These all had to be recorded and removed prior to the road extension taking place. This cemetery is highlighted because it is relatively large and has been very recently excavated and published; thus, it provides some of the most up-to-date information about a Roman cemetery in Yorkshire. The cemetery was also rather long lived, starting in the late first or early second century AD and remaining in use until at least the fifth century AD (and possibly longer).

Unfortunately, most of the remains of the adult graves were poorly preserved and could not be assigned to a sex, although across the immediate local area these recent excavations found a higher proportion of adult men in the twenty-six to thirty-five age group than was usual. Wider studies show that women had a generally higher mortality risk in the province. A large amount of metalwork in the Catterick region suggests that some individuals may be from a military community from Central or Eastern Europe, and one of the men buried at Bainesse may have been of African ancestry.

Forty-nine graves included iron nails surrounding the skeletons, showing that they were interred within a wooden coffin closed with iron nails. Some plant remains were found in

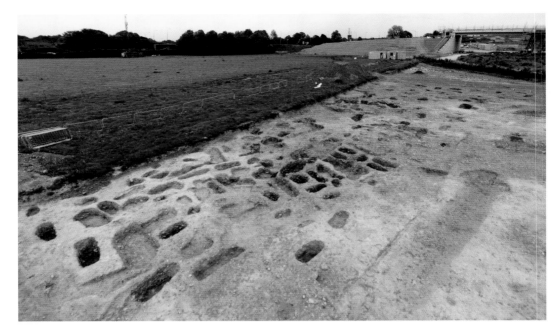

Above: The cemetery at Bainesse under excavation. A Roman cemetery in Britain looked quite different to the ordered graveyards we are familiar with today. Note that the grave cuts are close to each other and, sometimes, cut into earlier ones. (© Northern Archaeological Associates, used with permission)

Below: Grave 119 from Bainesse cemetery. Adult female aged twenty-six to thirty-five. The green rings show that she was wearing a copper alloy anklet on each ankle and a bracelet on her wrist. (© Northern Archaeological Associates, used with permission)

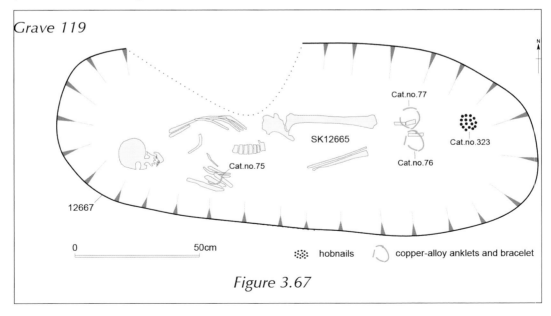

Figure 3.67

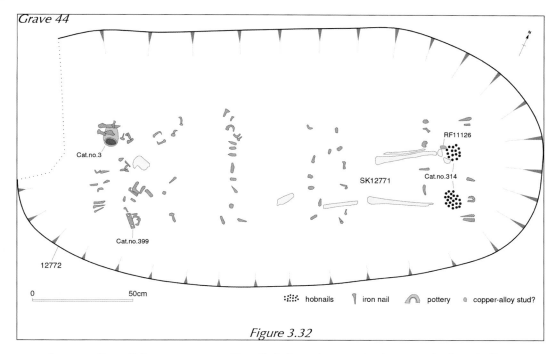

Figure 3.32

Grave 44 from Bainesse cemetery. Very little bone has survived, except the legs (still wearing boots), but the alignment of the iron nails shows that this adult was buried in a wooden coffin. A small ceramic jar was also placed by their head. (© Northern Archaeological Associates, used with permission)

them as well; for example, grave 120 is an inhumation of an adult male, aged twenty-six to thirty-five, who had the charred remains of wheat, ribwort plantain, some sort of tuber, clover, and peas included in his grave – probably from the funeral. While many of the inhumation graves had few or none of the human bones surviving, the soil conditions were good for preserving metals. Lots of the graves (thirty-five) have hobnails in groups, showing the position of their owner's booted feet in the grave. Occasionally the pattern that the hobnails originally made on the sole of the shoe can be discovered. Like many other Roman pagan cemeteries, some graves had ceramic jars (originally containing something) placed in them as well as personal possessions like knives or jewellery. Fourteen bracelets and anklets were located still worn on wrists and ankles by the deceased, glass beads were found in six graves and one of these was clearly formed into a necklace. Other personal possessions from the graves included a belt buckle, fishing hooks, whetstones, an iron pin, and a spare pair of shoes.

5

Religion and Magic

Religion, magic, superstition, and ritual were important parts of ancient life. Religious worship took place in homes, on the streets, at seasonal festivals and in small daily rituals. The many gods of the Roman pantheon were usually venerated individually, often with dedicated temples and priests to their aspects. In Roman Yorkshire, the many gods coexisted with one another, and each represented a specific aspect of life. Thus, we find Mars (the god of war), Venus (the goddess of love and passion), and Fortuna (the goddess of good fortune) alongside gods personifying Britain and the concept of Victory, as well as gods representing specific ethnicities or places. Just from York we can identify over thirty individual deities from altars, statues, jewellery, and other objects. In many cases, the inscriptions that we have found were dedicated by worshippers in fulfilment of a vow. This 'divine bargain' was central to Roman religion. Someone called upon a deity to help them out with a specific request (safe passage, recovery from illness, protection in battle, commercial success, etc.), promising a dedication to them in return. If it came to pass, they must hold up their end of the bargain. Many altars highlight this fulfilment of a contract with four letters at the end – VSLM. This is an abbreviation of VOTVM SOLVIT LIBENS MERITO, 'a vow willingly, and deservedly, fulfilled'.

These altars were normally dedicated at temples or shrines and they were a constant presence at certain places in the streets and roadsides of Roman Yorkshire. Many homes could have had a space for a small shrine, populated with figurines of favoured gods. It is important to remember that each individual could choose which deities they were most aligned to; there was no obligation to honour *every* god or goddess. Miniature, portable figurines of these gods were very popular. A bronze figure of Jupiter holding a thunderbolt was found in Ilkley, one of Vulcan is known from Catterick, and Mars from Yapham. Venus was most often depicted in a pale ceramic similar to 'pipeclay'.

Evidence for some religious practices remain very difficult to decipher entirely but the remains of these ephemeral rituals can be found. For examples, the discovery of pig, cattle and sheep skulls alongside mistletoe and holly in a large pond in Shiptonthorpe suggests the importance of this watery place and a connection to farming and seasonality being incorporated into the ritual. The burial of sadly deceased newborn infants, as well as a calf and a lamb beneath the walls and floors of buildings at Rudstone Dale, Newbald, is an

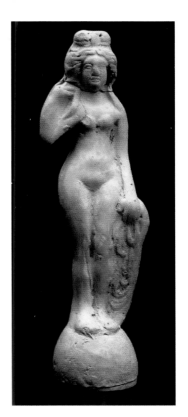

Ceramic figurine depicting the goddess Venus (the fine ceramic is often referred to as 'pipeclay'). Tanner Row, York, 1983. In the Yorkshire Museum (YORYM: 1983.32.2275). (© York Museums Trust (Yorkshire Museum), CC BY SA 4.0)

example of a 'foundation deposit' where burials were used to provide supernatural protection for new buildings. A well in Rothwell was evidently used for ritual deposits. Its contents included a human skull, skeletons of nineteen dogs and five cats, as well as parts of cattle, pig, and sheep/goats. Other deposits included leather shoes, pottery, and a quern stone.

Temples

Temples were dotted around the landscape and were particularly prominent in towns. At York we know of temples dedicated to Serapis, Hercules, Mithras, and the imperial cult. There is evidence of probable temple precincts at Catterick and Rothwell. In these cases, there is evidence of a large rectangular boundary (a *temenos*) with special or unusual deposits contained within it. At Rothwell there was the well (mentioned above), which might have been the focus for ritual deposits. At Catterick there were some unusual deposits, including an infant burial on the line of the boundary that contained a unique group of six fist-and-phallus pendants – a type of amulet.

The priests that served at temples are much harder to find in the archaeological record. We know of one priest called Marcus Aurelius Lunaris who was the *servir Augustalis*, the priest of the imperial cult (many Roman emperors were deified and worshipped) for both the towns of York and Lincoln. His name and profession were included on an

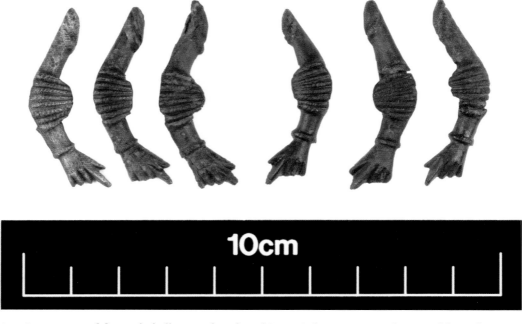

A unique group of fist-and-phallus amulets found in an infant grave on the sacred boundary of a probable temple or shrine precinct at Catterick. In the Yorkshire Museum (YORYM: 1980.54.9464.1-6). (© York Museums Trust, CC BY SA 4.0)

altar dedicated in Bordeaux to a goddess named Boudiga in AD 237 after a successful sea crossing from Britain. The role of a priest could be a social or political role as well as a religious one. Note that he made a dedication to a different god to the one he served to get across the sea safely.

Not all places of worship were stone or timber temples. The rural landscape of Britain was dotted with many small shrines, and we know of examples of these sort of structures at Millington in East Yorkshire and West Heslerton in Ryedale. Victoria Cave, near Settle, became a special shrine in the Roman period where access to a large inner chamber was

A bone spoon-like object with a perforated terminal from Dowkerbottom cave. The cave is near Kilnsey (North Yorkshire) in Wharfedale. Other objects like brooches and glass bangles were also recorded from the site. Drawing by the author. The original is in the British Museum.

available only through a small crawl space. The cave was found to contain many Roman objects when it was explored in the nineteenth century. It included jewellery, a Samian ware potsherd bearing the name Annamus, and a collection of unusual, bone spoon-like objects with perforations in each bowl. The spoon-like objects have been found in several caves in Yorkshire.

Local Gods for Local People

Roman polytheism allowed for a whole range of local and regional gods to be added into the classical religion. Sometimes native gods were associated with a similar Roman god; there is an inscription, found at Malton in 1835, to Mars Riga. We know very little about who Riga was, but it might have translated as 'king' from Celtic and so was seen as a powerful god not unlike the god of war worshipped by the Romans. Thus, the two were joined together.

Personifications of places were important in Romano-British religion. An altar at Ilkley was dedicated to Verbeia, which was probably the name of the River Wharfe and it might also have been the name of the fort here; so the goddess was the personification of the river or the fort and thus important to that place. Even if the names of the local deities

Drawing of the altar to Brigantia from Adel. The text is a straightforward dedication to the goddess and translates as 'To the goddess Brigantia, Cingestissa set this up'. (Reproduced by permission of CSAD and the Administrators of the Haverfield Trust)

53

were unknown, Roman religion had an answer for that – the *genii loci* (singular: *genius locus*) 'the gods of the place'. They represent the idea that all places have a spirit, or a soul, and that this needs to be respected. Dedications to the *genii loci* are found all across the north-western provinces of the Roman Empire. They are often wished 'good luck', like on inscriptions from Malton and York.

A popular goddess in Roman Yorkshire was Brigantia – a Romanised idea of a goddess of all of the Brigantes. It is unlikely that there was a single goddess called that before Roman paganism arrived, but Brigantia encapsulates the idea of a long history of habitation in this place. Worship of the goddess might have been a way for the Romano-British to connect with their ancestors, the idea of a free Britain, and/or the fearsome reputation of the tribe. Brigantia also represents the idea of a goddess of a beaten people, of Roman victory over the tribes in this area. There are altars to Brigantia at Adel and Castleford, and on Hadrian's Wall as well, which reflects the original reach of Brigantine territory. An altar was dedicated in AD 205 by Titus Aurelius Aurelianus at Greetland (near Halifax). The text described Titus as the *magistro sacrum* (master of the sacred rites), identifying the presence of a cult of Brigantia here; he may even have been a priest of the Yorkshire goddess.

Exotic Easterners

An altar to the god Mithras was found in York in 1747. It is a traditional depiction of the eastern god, in his heroic pose of killing a bull (the 'tauroctony' scene). Mithras is surrounded by numerous images: his torchbearers, Cautes and Cautopates, Sol and Luna;

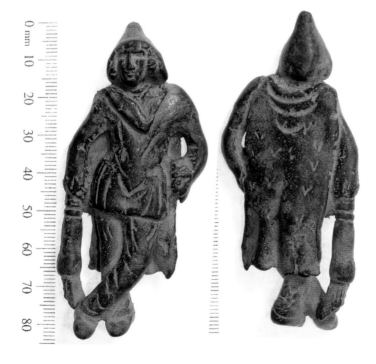

One of the torchbearers, Cautopates, from the Mithraic cult. He symbolises darkness, as his flaming torch is pointing downwards. Near Newton Kyme, 2007 (PAS: SWYOR-9FCBB3). (© West Yorkshire Archaeology Service, CC BY SA 4.0)

other human figures; and numerous animals, including a snake, dog, scorpion, and a raven. The cult of Mithras had its own set of rules and beliefs that ran alongside the Roman pagan religion. It was particularly popular with soldiers and the cult appears all over the Roman Empire, particularly on its frontiers. Meetings of the cult were held in long temples underground and its members had a series of ranks to pass through: Raven, Bride, Soldier, Lion, Persian, Sun-chaser, and Father. The tauroctony from York may have been dedicated in the temple in thanks for someone's promotion within the ranks of the cult. The figure of a man being helped into a chariot at the bottom right corner of this carving is good evidence of this. The cult was present outside of York as well – a figurine of Mithras' attendant Cautopates was found near Newton Kyme.

The presence of another temple to a different Eastern god is also attested at York. It is an inscription found at Tanner Row in 1770, so it was in the 'civilian' part of the city where we might expect temples to have been found. The inscription reads:

DEO SANCTO
SERAPI
TEMPVM A SO
LO FECIT
CL HIERONY
MIANVS LEG
LEG VI VIC

To the holy god Serapis, Claudius Hieronymianus, legate of the 6th 'Victorious'
Legion built this temple from the ground.

The legate was the man in charge of the legion and certainly had the resources to fund a temple. The god Serapis was first introduced in the third century BC in Egypt by the Pharaoh Ptolemy I as an attempt to unite the Greeks and Egyptians under his rule – Serapis has features of both classical Greek and Egyptian gods. The Emperor Septimius Severus and his family were based in York in AD 208–211 while Severus was campaigning in Scotland and he was a particular devotee of Serapis. It is likely that the legate was well aware of the emperor's imminent arrival in York and erected this temple to his favoured god in advance of the Severans. After his time as a legate, Claudius was promoted to the role of provincial Governor of Cappadocia (eastern Turkey) so his show of religious devotion to the imperial family's favourite god might have been a savvy career move as well as an expression of faith.

Amulets

Asking deities for help was one method of trying to stay safe and healthy, but the people of Roman Yorkshire undoubtedly owned and wore a kaleidoscope of different amulets, protecting themselves from all sorts of harm.

One of the most popular amulets was the phallus. It was almost always shown disembodied and erect and was used as a sort of lightning conductor against misfortune. There are over 150 phallic pendants from Roman Britain, twenty of which derive from

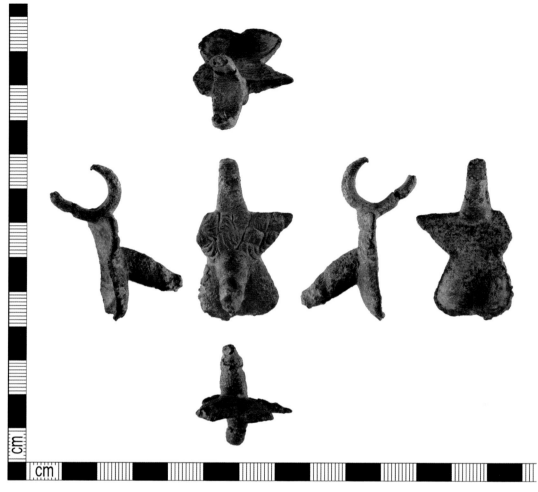

A rare example of a phallic pendant/amulet that depicts a flaccid phallus. Rotherham, 2013 (PAS: DENO-C0709A). (© Derby Museums Trust, CC BY 2.0)

Yorkshire. There are examples of two of the rarer types in Yorkshire as well. The first is a small, gold phallic pendant from Knaresborough – it is a hollow tube with a suspension loop behind it and is one of only three gold examples from Britain. It was an expensive piece of jewellery and is exceedingly rare. The other is a different sort of amulet, which might date to the first half of the Romano-British period, depicting a flaccid phallus in a more realistic portrayal. Flaccid phalli are much rarer amulets than erect phalli: there are thirteen examples from Britain, all in copper alloy, and two are from Yorkshire at Healam Bridge (near Catterick) and Rotherham.

Sometimes the phallus was conjoined with the image of a powerful gesture to enhance its supernatural protection. A clenched fist with a thumb held beneath the forefinger was the *mano fico* 'fig sign'. It was a rude gesture, but akin to the modern gesture of crossing the fingers for good luck.

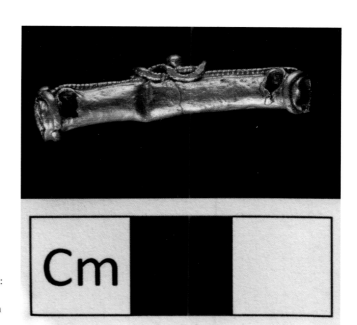

The gold amulet case from Castleford. In Wakefield Museums & Castles (WAKGM: 2003.26/SF510). (© Wakefield Museums & Castles, used with permission)

Funerary portrait of a boy wearing a horizontal amulet case, Egypt. In the National Museum of Warsaw (236767 MNW (127191).

Other amulets used magical words, prayers, and spells that were inscribed onto paper-thin gold sheets called *lamellae*. These were worn in a small amulet case. Translations of the text have found that they protected their owners from problems ranging from complications in childbirth to simple stomach aches. Amulet cases from York and Castleford probably contained a *lamella* each and were worn around the neck. The incredible survival of the Fayum portraits, from Roman Egypt, show painted portraits of the deceased, which were placed on the top of those mummified for burial. One such portrait shows a young boy wearing one of these amulet cases.

Early Christianity

Roman Yorkshire has a fair claim to being an important place in the early history of Christianity. Constantine the Great, proclaimed as emperor in York in AD 306, is famous for being the first Roman emperor to stop persecutions against the Christian communities of the Roman period. The Edict of Milan (AD 313) legalised Christianity and returned confiscated property back to the Church. Constantine was brought up under the influence of his mother, Helen, a devout Christian, but it wasn't until in his early forties that he formally converted to Christianity. This influence is celebrated in the canonisation of his mother as St Helena of Constantinople by the Catholic Church in later years. Eborius the

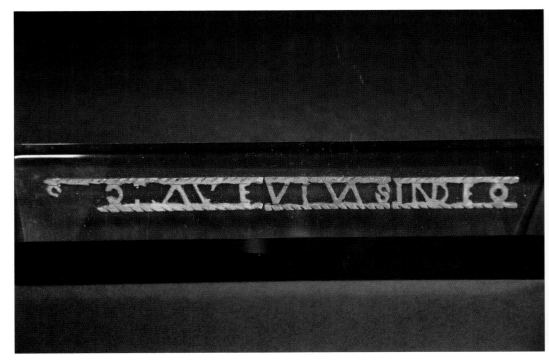

An ivory plaque from the grave of the Ivory Bangle Lady. Sycamore Terrace, York, 1901. In the Yorkshire Museum (YORYM: H5). (© York Museums Trust, CC BY SA 4.0)

Bishop of York was one of only three bishops from Britain to attend the first Council of Arles in AD 314, showing the central place of York and Yorkshire in the early adoption of Christianity in Britain.

Romano-British Christians are particularly difficult to find. There are markers that suggest that certain late Roman graveyards were from these Christian communities: inhumation graves aligned east–west with few, or no, grave goods included, but these are largely absent from the north of England. Occasionally we discover surviving objects with Christian iconography on them. One of the few definitively Christian objects from the region comes from the grave of the Ivory Bangle Lady at York. It is an ivory plaque, carved into with the phrase:

AVE SOROR VIVAS IN DEO

Hail Sister, may you live in God!

This Christian phrase does not, however, prove that the lady it was buried with was a Christian, but only that there was a community of Christians in late Roman York. The north–south alignment of the burial and the inclusion of other objects in the grave is more suggestive of a pagan burial into which a Christian object has been placed by someone to whom it held more religious significance.

There is a possible early church at Beadlam villa. It was a 10-metre-long building aligned on an east–west axis with an apse at the eastern end. This is a tentative identification, but it is surprising that there aren't more of them around.

6

Everyday Life and Leisure

The Roman period in Britain lasted from the middle part of the first century to the early fifth century AD and throughout this wide expanse of time there were many changes in how people lived. During the invasion there was a clash of cultures between the native British and the invading Roman Empire. Eventually these became blended together into the Romano-British. Britain, and indeed Yorkshire, had its own identity but was firmly part of the wider Empire. This mixture of local, regional, provincial, and inter-provincial identities came together in a cultural boiling pot. It is an impossible task to introduce all of the changing identities, changing fashions, changing foods, and changing habits of this period in one short chapter. Thankfully, there are plenty of treasures on which we can focus in order to tell the wider story.

Dress

The arrival of the Roman military and the continued occupation of Britain as a Roman province resulted in slow, but long-term changes in traditional dress styles. The gradual adoption of Roman material culture took place over several generations – the evidence from Shiptonthorpe and Hayton in East Yorkshire is that new dress styles (such as brooches) arrived early in the invasion period when their owners probably still lived in the traditional roundhouses characteristic of the pre-Roman Iron Age.

Dress had social status and gendered implications in Roman Yorkshire. The principal garment of Roman Britain was the 'Gallic coat', a single-piece fabric tunic with or without short, wide sleeves that could be worn by both men and women. The *birrus* was a larger cloak worn over the top of the tunic. Soldiers had their own distinct off-duty dress: a shorter tunic worn with a military belt and a rectangular cloak. Tombstones that included sculpted portraits are a helpful way of showing different sorts of fashions. They might be presenting an idealised or an aspirational version of what the person wore, but the fashions were at least based on existing trends and designs. The tombstone of Lucius Duccius Rufinus, a standard-bearer of the 9th Legion who was commemorated in York, is depicted in his off-duty clothing but holding his symbol of office – the *vexillum* (the military standard, a

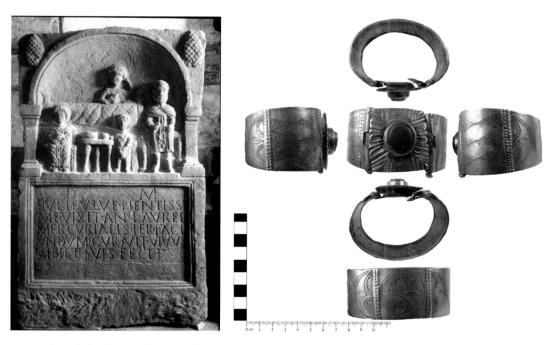

Above left: The tombstone of Julia Velva, served by a slave and attended by her heir. Note the differing dress styles of these three characters. In the Yorkshire Museum (1998.25). (© York Museums Trust, CC BY SA 4.0)

Above right: High-status bling: a silver bracelet dated to the third century AD from near Doncaster (PAS: SWYOR-B51685). (© Portable Antiquities Scheme, CC BY SA 2.0)

sort of unit insignia). Julia Velva, also at York, was depicted reclining on a dining couch in her tunic with her hair worn up and pinned at the back. She is being enslaved attendant wearing a simple tunic and belt and joined by her heir – Aurelius Mercurialis. Aurelius is wearing a cloak gathered at the neck over his tunic and a pair of large boots. The figure seated at the left is probably a mother goddess sitting in a wicker chair wearing a modest, floor-length shawl and holding a bird.

Ivory Fan Handles

To think about dress and fashion, let's consider two case studies. First, let me introduce something truly exotic from Roman Yorkshire. A pair of 32-cm-long ivory handles came from a badly recorded grave excavated at the railway station in York in the nineteenth century. Spaces in the upper faces of the handles were designed to hold a concertinaed piece of leather or papyrus to create a fan. The handles are unique in Roman Britain and one of the largest ivory objects too. Four other examples are known from the near Continent. A tombstone from Carlisle (in the Tullie House Museum) depicts a seated woman fanning herself with one of these circular fans – the size and prominence of this

Ivory fan handles from a circular fan. From a grave found during the Railway Excavations. In the Yorkshire Museum (YORYM: H304). (© York Museums Trust, CC BY SA 4.0)

object on the gravestone goes a long way to articulating its meaning. Ivory was rare, and ivory-handled fans particularly rare. Undoubtedly this was a high-status object – something for the wealthiest people of Roman York. Remember that York was the administrative and military centre of Roman Yorkshire, was the seat of the governor and was visited by emperors – exactly the sort of place where we might find evidence of the rich and powerful. This object was a symbol of power: it was a symbol of leisure made from an exotic material from the furthest edge of the empire and was used in a way that showed this off. The fan was certainly not a symbol of 'everyday life' for all but the richest minority.

Leather Shoes

To look at the other end of the scale, we need only turn to shoes. Large-scale leatherworking arrived in Britain with the Romans, so the styles that we find here are paralleled across the north-western parts of the empire. Shoes were ubiquitous in Roman Britain and came in adult and children's sizes. Styles changed in shape and size over time to reflect current fashions. Usually, they were made from several pieces of leather sewn together and had iron hobnails underneath. They could be worn on bare feet like sandals or with thick socks to provide some extra warm and comfort. Lots of shoes have evidence of repairs on them, either to the leather or to replace lost hobnails, showing that they were

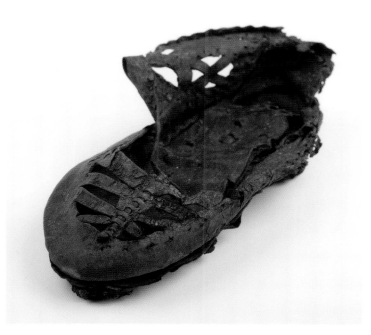

Right and below: A Roman child's shoe. The sole is formed from several layers of leather pressed together with iron hobnails underneath. Note the openwork decoration on the top. It was tied by a pair of straps or binding from the top of the shoe around the ankle. In the Yorkshire Museum (YORYM: 2009.46). (© York Museums Trust, CC BY SA 4.0)

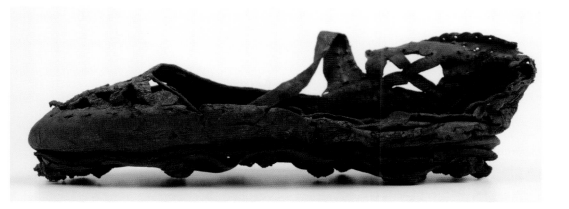

an important piece of clothing that should be looked after. Many Roman graves provide evidence of people wearing these hobnailed shoes (see Chapter 5). There are lots of fragments of leather from the military sites at Castleford and at Catterick, which seems to have been important in the regional leather trade. One of the preserved writing tablets from the fort of Vindolanda on the Hadrianic frontier further north mentions this. In it, Octavius wrote a note to his brother Candidus asking for some money. The two seem to be traders and Octavius had put a deposit on 5,000 *modii* of grain and needed some more money from his brother to seal the deal. In the letter he asks that he wanted to drive his cart to Catterick to collect a shipment of hides but couldn't because of the poor winter weather.

There were many kinds of personal adornments to set off an outfit. Brooches were worn by both men and women to pin clothing and gather cloaks; the dragonesque and fantail types were particularly popular in the north of Britain. Finger rings and a whole range of pendants too could be worn by both sexes. Anklets and armlets were present too, as well as the occasional Iron Age style torc. The archaeological evidence from graves suggests that earrings and hairpins were strongly associated with women.

Gallus Priest

One particular exception to this rule is a fascinating grave from Catterick. In it a biologically male skeleton was adorned with characteristically female jewellery. This is really unusual in Roman Britain. The best interpretation that we have of this grave is that it belonged to a type of priest called a *gallus*. The *galli* were priests of the cult of Cybele, one of the Eastern gods. Cybele was a mother goddess and her priests, in deference to the myth

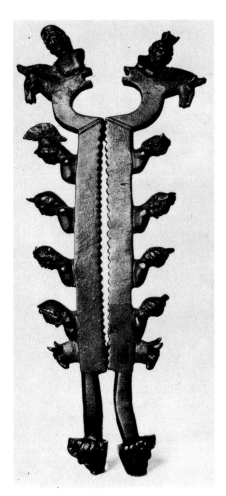

A pair of copper alloy clamps from Roman London, with Cybele and Attis at the apex, and the busts of other deities along their length. They are believed to be associated with the cult and might have formed part of the castration ritual.

surrounding her consort Attis, ritually castrated themselves as part of their initiation into her service. After undergoing this traumatic procedure, the *galli* wore stylistically female clothing (especially in the colour yellow) and otherwise presented themselves as women. The Catterick *gallus* is an important case study in showing the diversity of Roman Britain while challenging some twenty-first-century assumptions that we might make towards ancient societies.

Catterick Theatrical Mask

Other objects may have been worn for specific religious festivals, such as this theatrical mask. There was a long tradition of acting in the ancient world. In fact, a lot of the classics, the ancient texts that have survived, were meant to be performed. Tragedies by Euripides, comedies by Aristophanes, and the plays of Plautus and Terence might be familiar names. Theatrical performances were both entertainments and often linked to important religious functions. In Greco-Roman theatre, the actors often wore masks to help the audience to identify their characters. A ceramic mask was discovered at Catterick in 1972. It is part of a very small group of these objects known from Roman Britain. There is also an ivory

Characters in ancient theatre were recognisable by their masks. This ceramic mask is reconstructed to show the original shape. In the Yorkshire Museum (YORYM: 1985.27.1). (© York Museums Trust, CC BY SA 4.0)

'tragic' mask from Caerleon (southern Wales) and another ceramic one from Baldock (Hertfordshire).

It has been reconstructed to show the full face. It has two large holes for the actor to see through, a long, straight nose and a small slit for the mouth. A pair of small points projects above the head, but these are not horns but hinges. They have a small hole running through each side and may have connected to some sort of cap or helmet to allow it to be lifted up or down. The presence of a mask does not mean that there was a formal theatre at Catterick as travelling bands of actors may well have brought their productions to rural and military places.

Dining

The range and character of the food eaten across Roman Yorkshire was not any different to that consumed across Britain as a whole. Seasonal foods were foraged, farmed, preserved, traded, and imported and the access to the widest variety of different foodstuffs was entirely dependent upon being close to the supply chain and having the money to tap into it. Large urban centres, understandably, were points in the wider landscape where more and different foodstuffs could be available, especially those imported from elsewhere in the empire.

Tiny fragments of plants have been readily preserved in the waterlogged conditions at York. The environmental remains there have been well studied and show that oats, wheat, and barley were cultivated nearby and used in the city. Imported olives, lentils, grapes, mulberries, and figs have been found as well as evidence for the consumption of chicken, duck, sheep/goat, cattle, crab, oyster, mussels, and dormice. The fields surrounding Roman settlements grew the crops and housed the animals needed for these places to thrive. Springs and rivers provided fresh water for cooking and cleaning as well as fish stocks.

The most common tablewares are all ceramic, but metal and glass can also be found. Roman glass is often intricately detailed; it could be formed in a mould to produce detailed figures, animals, or foliage, or blown and decorated with trailed molten glass on the surface. Glassware was also functional – the larger blue-green glass bottles used as storage jars for food and liquids are commonly found throughout Yorkshire. Specialist kitchen equipment could probably be found in most households: rotary hand querns could be used to grind wheat into flour and *mortaria* were wide, rough-surfaced bowls used to prepare ingredients and sauces.

The Roman amphora is a well-recognised object from the ancient world. They were large storage jars with a pointed base so that they could be kept stable on ships or carts; the body slotted into a circular hole in a wooden frame alongside many other jars. The different shapes and materials they are made from are often clues to where the amphorae were made, and thus probably where its contents were imported from. Many thousands of fragments of these jars have been found in Yorkshire as well as a few whole ones. Many of the forms are numbered according to a sequence devised by Heinrich Dressel in the late nineteenth century. Dressel type 20 amphorae are wide, globular jars produced in Spain in the first to third centuries AD and they have been found in York, Aldborough, Doncaster, Catterick, Templeborough, and Rudston. Dressel type 7-11 ('salazon') amphorae have been

Amphorae had to be hard-wearing vessels so they could protect their valuable contents on journeys covering hundreds of miles. The thickness of the ceramic jar can be seen on this handle fragment from East Yorkshire (PAS: YORYM-390BF5). (© Portable Antiquities Scheme, CC BY SA 2.0)

found in York and Aldborough – evidence from jars on wrecked ships shows that they mainly contained *garum*, a sort of pickled fish sauce that was an important ingredient in many recipes in the Roman world. Some other examples of these amphorae have been found to contain wine or *defrutum*; a grape syrup made by boiling down grape juice in large kettles.

Amphorae were designed to be transported. A few types were made in Britain, but many came in from sea trade. Catterick is one of the northernmost points in Roman Yorkshire, and more than a day's journey from York by road. The most common amphorae found there is the Dressel 20, containing olive oil, followed by the Gauloise 4, which was used for wine. Evidence for the commodities oil, wine and *garum*, are commonly found across Roman Britain. Sometimes the amphorae were painted or inscribed with details about their contents or where they came from. A sherd found in 2015 near Barlby in North Yorkshire was inscribed with a very precise date: 'In the consulship of Severus and Sabianus, on the fifth day before the Kalends of September.' This date equates to 27 August 155 and it is from a Dressel 20 oil amphora, so the owner or wholesaler knew exactly how old their produce was.

A Lucky Cooking Pan

Cooking equipment was either ceramic or metal, with different materials suiting different types of cooking. Small metal pans, *paterae*, were used for cooking sauces. They could also be used in some religious rituals. One particularly fine example from Yorkshire is a pan with enamelled decoration found at Eastrington in East Yorkshire. The body is decorated in a chequered pattern of blue, green, yellow, and red enamelled squares. The handle includes an enamelled inscription 'UTERE FELIX' – 'Good luck to the user' or 'Use, with luck'.

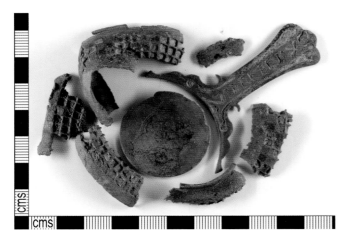

An amazing survival of a really unusual pan. The body was decorated in bright enamel and the handle included the phrase 'UTERE FELIX'. When it was new the green colouration of the copper alloy would have been bright and brassy (PAS: YORYM-20B68C). (© York Museums Trust, CC BY SA 4.0)

Knaresborough Metalwork Hoard

In 1864, a large collection of copper alloy pots and pans was found at Knaresborough. A large portion of this hoard was accidentally melted down shortly after it was discovered, but the surviving objects are still the largest copper alloy hoard from Roman Britain. It included handled skillets, wide plates and platters, and tall jars. Several of the pans had tiny holes pierced into them so they could be used as strainers. These holes made distinctive and attractive patterns in the vessels. Why would someone put their kitchen pans in the ground? Well this much metal was certainly valuable – most cooking and storage vessels were made out of cheaper pottery. We think that there are two main reasons that groups

A platter fit for a god? This large hoard of copper alloy pots and pans was found in Knaresborough in 1864. In the Yorkshire Museum (YORYM: H114). (© York Museums Trust, CC BY SA 4.0)

of coins or objects were placed into the ground in a hoard. Simply put, hoards were either ritual dedications to a deity or supernatural power, or a sort of safety-deposit box. The value of the hoard could have been an important thing to prevent from being stolen or to have kept safe while the owner was away travelling. Equally, it would have been a pious and generous gift to a god.

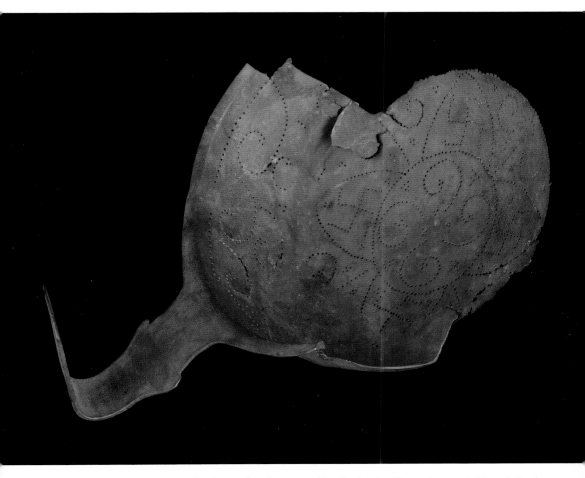

Decorative perforations on the base of a sieve or collander in the Knaresborough Hoard. In the Yorkshire Museum (YORYM: H114.5). (© York Museums Trust, CC BY SA 4.0)

7

Commerce

Small change was widely used throughout Yorkshire in the Roman period. It is still commonly found today. The Portable Antiquities Schemes has recorded over 20,000 Roman coins found by metal detectorists in Yorkshire since 1997. Small change was abundant, and most coins were issued in copper alloy. Roman coinage changed dramatically over the first four centuries, with several new denominations being issued and a greater use of silver coinage in the first two centuries of Roman Britain followed by more copper alloy coinage after this date. Gold coins were extremely rare.

One of the easiest ways of looking at money is to look at soldier's pay, as we have lots of good evidence for this. At the end of the first century basic legionary pay was 300 denarii a year (more for senior ranks or those on special duties) and less for the *auxilia* – this came in several instalments a year, with deductions made for weapons and armour, for rations, and a payment into the burial fund. If paid three times annually, each instalment was up to a maximum of 100 denarii. The gold coin at this time, the aureus, was worth twenty-five times

Rare coinage. A gold aureus issued by Emperor Domitian in AD 73. From Pocklington, East Riding of Yorkshire (PAS: DUR-776A00). (© Durham County Council, CC BY SA 4.0)

that of a denarius. It wouldn't have happened, but it was economically possible for a soldier to be paid four months wages in just four high-value coins. Very few people would have ever handled such a high-value coin, and spending it might not have been easy. They were rare in circulation, but they, and silver coins, are also less likely to be found than copper alloy examples because their owners probably dedicated more time to finding any dropped or missing coins of these denominations than they would to small change. Some precious metal coins were also officially removed from circulation and melted down and recycled.

Tadcaster Arm Purse

One of the ways that coins were kept safe was by carrying them in an arm purse. These copper bands are hollow inside so that coins could be held tight against the arm that was wearing it. Of course, textile bags of coins existed, but this sort of metal container was a lot harder to remove. Discovered in Tadcaster in 2005, this arm purse was found to still contain 4 silver denarii of Commodus (emperor AD 177–192) – enough coins to buy a fine pair of boots or several jars of good wine.

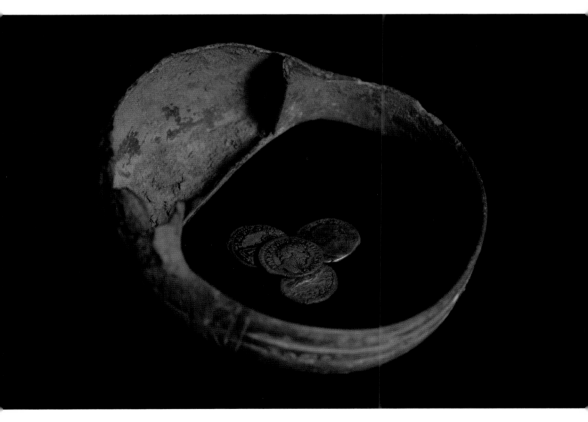

Several coins could be kept safe by putting them in this purse and wearing it over the arm. In the Yorkshire Museum (YORYM: 2007.6299). (© York Museums Trust, CC BY SA 4.0)

Coin Hoards

Banks did exist in the ancient world, but we don't know of any bankers from Roman Yorkshire. Many people stored coins in containers, some of which were eventually buried. A group of more than two coins found together is technically classed as a hoard, but they could get very large indeed – sometimes having thousands of coins together in one place. Some hoards were added to again and again and could have functioned as a sort of safety deposit box. Other hoards may have been buried as a votive gift to a deity. There are over 260 hoards of Roman coins recorded from Yorkshire.

At the small end of the scale are examples like the Binnington Carr hoard, which contained 12 denarii dating to AD 74–75 buried within a large bronze bell, and the Overton hoard of 37 denarii. It is unsurprising to find that half the hoards in Yorkshire contained fewer than 100 coins and these are mainly small copper denominations.

At least twenty-three hoards contain over a thousand coins, and these are mainly small copper denominations. Examples of larger hoards include the Braithwell hoard of 1,331 third-century radiates, the Wold Newton hoard of 1,857 *nummi* along with one radiate, and the Cridling Stubbs hoard of over 3,300 fourth-century *nummi*. These last two were both within ceramic jars, the most commonly found container. The largest reported hoard from Roman Yorkshire was found in Swine, north-east of Hull, in 1826 and contained over 14,000 coins.

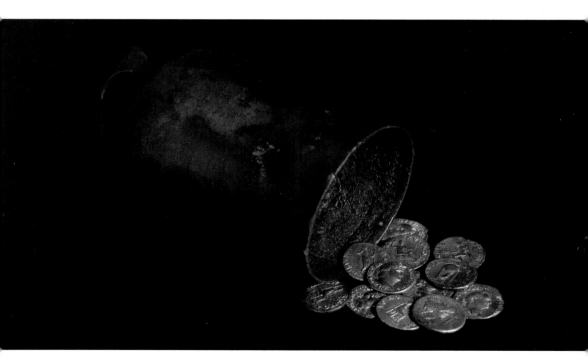

Coin hoards came in all sorts of sizes. With only twelve silver coins deposited inside a large bell, the Binnington Carr hoard was relatively small. In the Yorkshire Museum (YORYM: H2401). (© York Museums Trust, CC BY SA 4.0)

Wold Newton Hoard

In September 2014, a metal detectorist struck metaphorical gold in a field near Wold Newton – a ceramic jar filled to the brim with Roman coins. Many of the buried hoards have been disturbed by ploughing and their coins scattered across their fields, but this was one of the lucky ones. The coins were left in the vessel by the finder and it was carefully micro-excavated by the conservation team at the British Museum. This showed that the coins were added to the hoard in layers over time – a few thrown in at one time, a few thrown in at another. All told, it contained 1,857 copper alloy coins. Of these, one is a type known as a radiate, the remainder are *nummi* – copper alloy issues used as small change. The total value of the coins was worth more than a year's wages for an ordinary citizen. It was sealed or deposited in AD 307, shortly after Constantine the Great was proclaimed emperor in nearby York.

The hoard was declared treasure (in the legal sense). A fundraising campaign in 2016 by the Yorkshire Museum was successful in raising the £44,200 to keep it in a public collection.

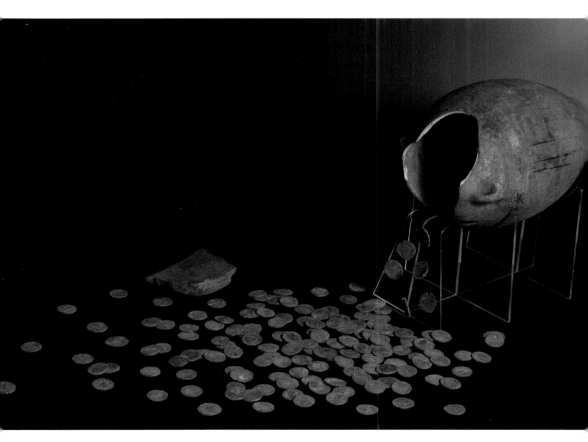

The ceramic jar from Wold Newton was found to contain nearly 2,000 individual coins. In the Yorkshire Museum (YORYM: 2016.566). (© York Museums Trust, CC BY SA 4.0)

Lingwell Gate Coin Moulds

Precious metal coins were incredibly valuable and so it is unsurprising that a healthy industry in forgery could be found in Roman Britain. For example, of the approximately 12,800 Roman coins recorded by the PAS in East Yorkshire, nearly 900 (7 per cent) are forgeries. A fascinating discovery from Lingwell Gate in Wakefield, West Yorkshire, was a group of moulds used for forging coins. They were found in large batches between 1697 and 1840. A report in the Leeds Intelligencer on 13 April 1826 recorded 'a wheelbarrow full' found on 13 March 1821.

Genuine coins, issued in the name of the emperor, were struck using coin dies onto blank coins. Forgers could make fake coin dies or, like at Lingwell Gate, make casts of existing coins. Real silver denarii were pushed into clay to make a mould of an upper and lower half of each coin. Several of these were stacked together and a lower quality (base) silver was poured into the holes at the edge of the moulds. After being cleaned up, the resulting fakes passed as real and entered circulation. These coins date from the first to early third centuries AD. The benefit to the forger was to make enough coins from the cheaper, lower-quality silver that they were worth a lot more at a face value than their actual silver content. Obviously, this was illegal, but the operation at Lingwell shows that some people were willing to risk it.

A stack of coin moulds for making forgeries from Lingwell Gate. In the Yorkshire Museum (YORYM: H2402). (© York Museums Trust)

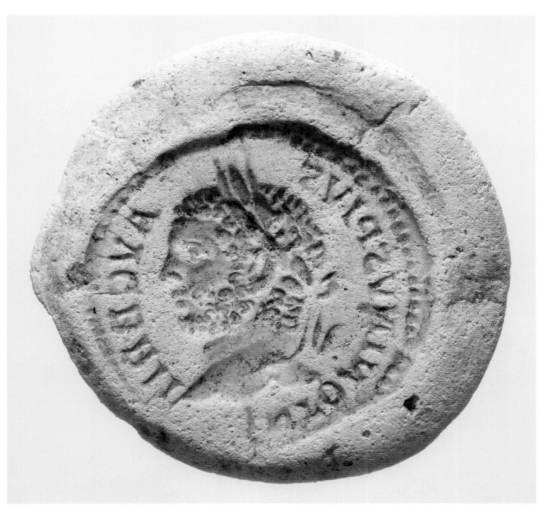

One of the coin moulds from Lingwell Gate. It depicts a denarius of the Emperor Antoninus Pius (AD 138–61). In the Yorkshire Museum (YORYM: H2402). (© York Museums Trust)

8

Trade and Industry

Although it was at its north-western fringe, Roman Britain was still able to access connections to the wider Roman Empire. International imports of olive oil, wine, and the traditional fish sauce *garum* are well known and there were also significant amounts

The Yorkshire fortress: the south-west corner tower of the fortress at *Eboracum*, which still stands today. Known as the Multangular Tower, it is built from Magnesian Limestone bricks, of a type that was brought into York from elsewhere in Yorkshire.

of internal trade within the province. This was especially true for trade within different regions of Britain. In some cases, this trade is pragmatic; for example, the pale yellow-white stone visible in the Multangular Tower in York is the typical limestone used throughout Eboracum. Geologically it is a 'Magnesian Limestone', but archaeologically it had been transported here from elsewhere in Yorkshire. The Roman settlement at modern-day Tadcaster was a probable major source; the Latin name of that town, Calcaria, is taken from its connection to the stone. The limestone was an easier material to work and carve into dressed stone blocks than the natural coarse-grained sandstone that is the bedrock of York itself. Elland Flag, from near Leeds, was also used in roofs at Shiptonthorpe. So local resources were exploited where it was practical and viable to do so. In this section I will introduce some of the 'Yorkshire' flavour of regional trade in Roman Britain.

Enamelled Brooches

Fashions changed quickly in Roman Yorkshire. A group of copper alloy brooches with enamelled decoration may have been produced in the region. So-called 'headstud' brooches were decorated with one or two circular studs at the apex of the bow. We know that Castleford was producing enamelled metalwork because more than twenty-five fragments of crucibles have been found here as well as hundreds of clay moulds for all of the metal products. These include some types of brooches, such as the headstud type.

The brooch in the image was found in Featherstone, just south of Castleford, and appears to be unfinished. Copper alloy is bright and brassy – the green on the surface is a product of its oxidation. When you look at it, think of the bright and garish colours these brooches originally contained. They were small, functional, but impactful accessories. It is plausible that it is one of the products of the local brooch production industry.

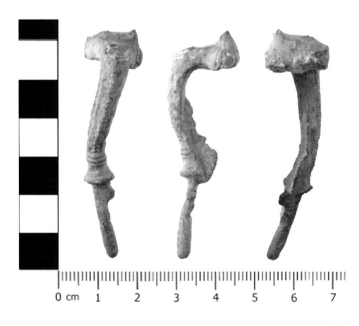

Bright copper alloy headstud brooches with colourful enamel decoration were a popular dress accessory in Roman Yorkshire and were made in the Castleford area. From Featherstone, near Castleford (PAS: SWYOR-92A6C9). (© West Yorkshire Archaeology Advisory Service, CC BY SA 4.0)

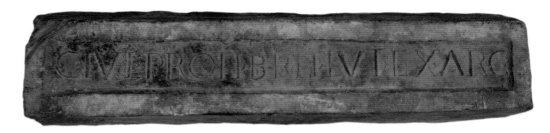

One of the four lead pigs discovered at Brough in 1939. In the Hull & East Riding Museum (KINCM: 1942.1002.1). (© Hull and East Riding Museum: Hull Museums)

Lead Pigs

A group of large lead ingots, known as 'pigs', have been found around Brough. There are at least nine of them from this area. Each pig measures nearly 60 cm in length and weighs around 85 kg. Several are inscribed with the abbreviation 'SOCIO LUT BR EX ARG', which translates as: 'The product of the Lutudarisensian partners: British lead from the lead silver works.' The lead ore used to make these ingots could be a by-product of silver mining. It was found in the form of the mineral galena (lead sulphide), which occurs in the Carboniferous limestone regions of Britain – the Mendips (Somerset), Flintshire (North Wales), Shropshire, Derbyshire, and Yorkshire. The naming of the production place on some of the pigs located their origin to the site of Lutudarum in Derbyshire. The products of the Derbyshire mines were probably sailed down the River Trent to Brough before being transported by sea elsewhere in Britain or, more likely, to the Continent.

Ceramic Production

Ceramic tableware was much more commonly used than the metal plates and jars that made up the Knaresborough Hoard. With links to the empire, there are numerous types and forms of pottery imported into Roman Britain – olive oil amphorae from the Mediterranean, the commonly found glossy red Samian ware from Gaul, and dark brown beakers from the Rhineland bearing mottos in white paint, such as 'Long life to you' and 'Drink [up]'.

Clay was cheap and easier to acquire and so it is not surprising to find a whole industry of potteries in the region. The different clays found throughout Yorkshire each had naturally different compositions. Roman potters could also add in sand, shell, or other hard materials as a 'temper' – to help prevent the pot from breaking when it was baked in the kiln. These differing properties, along with different traditions for making certain types or sizes of pot in different places, created a landscape of different pottery 'wares' throughout Roman Yorkshire. Some of the earliest ceramics were made by the army. The 9th Legion in York made floor and roof tiles to be used in the early fortress. Small units also made ceramics: the Cohors IIII Breucorum produced *mortaria* (wide grinding bowls for food preparation), roofing and hypocaust tiles in the pre-Hadrianic period at Grimescar,

5 km east of the fort at Slack. These stamped tiles are used at Slack, also at Castleshaw and Castleford, as well as Manchester, showing that not every fort needed to produce its own supply.

Cantley Kilns

Over forty kilns have been found in the area south and east of Doncaster, centred around Cantley and Rossington Bridge. They started producing local wares in the mid-second century. Different kilns may have been owned by different potters and were probably used at different times, but the density of kilns here shows that this was a landscape of potters. It can be quite variable, but the main sort of ceramic produced here is particularly hard and dark grey in colour. Many of the jars were burnished – polished smooth before they were fired in the kiln – and so took on the shiny, dark lustre of this process.

Potters making *mortaria* often stamped their names on the rim of the vessel. We know of Sarrius, Setibocius, and Secunda all making these vessels in Cantley in the period *c.* AD 135–170, and Virrinus who was working slightly later, *c.* AD 150–180. Sarrius may have also had close connections with, or even owned, other potteries in the Midlands at the Mancetter-Hartshill region. His *mortaria* have been found on the Antonine Wall, Corbridge, and Catterick but Doncaster and its hinterlands were the long-term main consumer of the pottery from Cantley and Rossington Bridge.

Dark jars and dishes were the typical products of the Cantley kilns. This rim fragment was found in Edlington, only a few miles from its production site (PAS: SWYOR-3F1141). (© West Yorkshire Archaeological Services, CC BY SA 4.0)

Crambeck Ware

The fourth-century pottery industry based around Crambeck, between York and Malton, produced some of the most astonishing pots in Roman Britain. The typical Crambeck vessel was made from a pale cream-coloured fabric and decorated with a thin red paint at

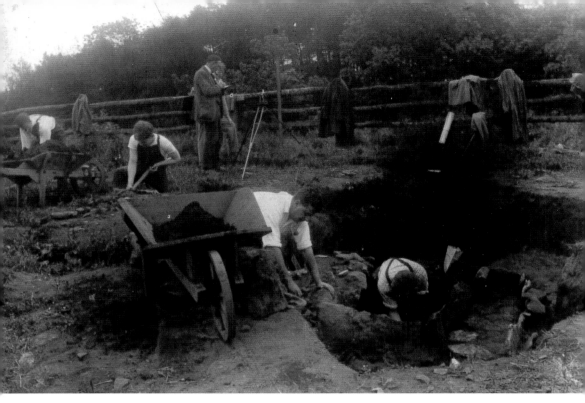

Excavation of a kiln at Crambeck by Philip Corder in 1926–27. The rounded shape of the kiln, in which a man is standing, can be made out in the lower right corner. In the archive of the Yorkshire Museum.

This pale yellow fabric with red-painted decoration is a typical product of the Crambeck kilns. It is a rim sherd of a mortarium, the deep bowls used for preparing sauces. In the Yorkshire Museum (YORYM: H5004). (© York Museums Trust, CC BY SA 4.0)

A local product for local people: a decorated rim sherd of a Crambeck product from Preston, East Yorkshire (PAS: NLM-69F403). (©North Lincolnshire Museum, CC BY SA 4.0)

its surface. It doesn't seem to have been distributed too far beyond the north and east of the country, with its greatest popularity firmly within Yorkshire.

In most other places in Britain by this time the dead were buried in the ground (inhumation), but in Yorkshire a tradition of cremation continued at the same time. The Crambeck ware industry is noted for the creation of cremation jars with human faces – whether they depicted the individuals contained within them (like on a tombstone) or a patron deity we can only speculate. Other playful designs included stripes, dots, stars, and stick figures.

Whitby Jet

Whitby jet is a type of coal formed from the fossilised wood of *Araucaria araucana* (monkey puzzle tree). It has outcrops in the North Sea so pebbles of it wash up on the Yorkshire coastline, especially near Whitby and Robin Hood's Bay. Jet is a hard, but lightweight material, which can be polished to a bright finish and can easily be worked with metal cutting tools; all of which make it ideal for jewellery. The Romano-British weren't the first to use it in Yorkshire as it had been used for jewellery here from at least the Bronze Age (c. 4,000 years ago). Jet is a uniquely Yorkshire material, but other similar types of coal

could be used for the same purpose, so we also find shales and Kimmeridge coal used in Roman Britain. York was probably the centre of the jet production industry and sold its products throughout the region, but especially to Roman towns in the south – to London and Colchester in particular. Yorkshire jet has even been found in central Germany and northern France.

It was used for bangles, bracelets, necklaces, and hair pins and was probably mainly worn by women. Two types of jet object are particularly interesting. The first is a group of eleven pendants depicting the Medusa – the mythical gorgon who turned people to stone and was beheaded by the Greek hero Perseus. Four have been found in York, the rest outside of Yorkshire. Where we can tell, they were worn in the grave by young adult women (aged eighteen to twenty-five). One pendant from a grave in Walmgate was found with hundreds of beads attached and was worn on the centre of the young woman's chest.

The second group of unusual objects is a group of figurines depicting bears and big cats. There is one from York and one from Malton, with the remainder from the south-east. These were all found in the graves of infants. Jet is electrostatic, so it takes a static charge and could attract hair or cloth fibres when it was rubbed. What is fascinating is that some of the Medusas and figurines are worn smooth from where they have been rubbed. This unusual physical property made jet seem exotic or even magical and was probably associated with supernatural protection. The tragic early deaths of the children and women are commemorated through the inclusion of these sorts of powerful amulets in their graves, to protect them in the afterlife.

A particularly fine product of the Whitby jet workshops in York, this Medusa pendant is one of four from York. Eleven are known from Britain and twenty-two from the north-western provinces of the Roman Empire. In the Yorkshire Museum (YORYM: H321.14). (© York Museums Trust, CC BY SA 4.0)

Probably the most common object made from Whitby jet was the hair pin. This classic example has a cuboidal head with the corners removed. In the Yorkshire Museum (YORYM: 1995.176). (© York Museums Trust, CC BY SA 4.0)

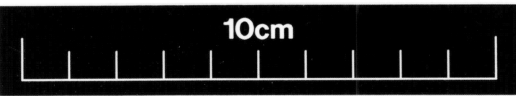

The raw material: a 'roughout' (part-worked) fragment of Whitby jet. In the Yorkshire Museum (YORYM: 1995.174). (© York Museums Trust, CC BY SA 4.0)

9

Families and Social Status

Local Government

Roman society was divided into several social classes, based on the rights of citizenship and the wealth and status of individuals. Citizenship afforded some legal rights and protections like the rights to vote or stand for civil office and own property, though they were different for freeborn men and women, and for freedmen (emancipated enslaved people).

Some of the citizens with the highest social class in Yorkshire were the legates of the Roman legion, people like Quintus Antonius Isauricus in the second century and Claudius Hieronymianus who erected the temple to Serapis in York at the start of the third century AD. Certain civic duties were only available to people of certain social ranks. For example, the decurions were elected from the middle classes – the *eques* – who were part of the systems of local governance and contributed their own wealth to investing in public-spirited buildings projects. Flavius Bellator was one such decurion, named on his sarcophagus in York. He was buried wearing a gold ring, the visual marker of his social status as part of the middle class. Marcus Ulpius Januarius was an *aedile* of the vicus of Petuaria (Brough), responsible for public order and the maintenance of public buildings. His partial dedication reads:

OB HONOR[EM]
DOMVS DIVI[NAE]
IMP CAES T AEL H[ADRI]
ANI ANT[O]NINI A[VG]
P P COS I[I]
ET NUMINIB A[VG]
M VLP IANVAR[I]V[S]
AEDILIS VICI PETV[AR]
PROSCAEN
DE SVO [DEDIT]

The stone marking the dedication of a theatre by Marcus Ulpius Januarius at Brough-on-Humber. In the Hull and East Riding Museum (KINCM: 2000.195.489). (Courtesy of Bernard Sharp, CC BY SA 2.0)

> For the honour of the Divine house, of the Emperor Caesar Aelius Hadrianus Antoninus Augustus, Father of his country, consul, and to the Spirits of the Augusti, Marcus Ulpius Januarius, Aedile of the vicus of Petuaria, [gives] a stage at his own expense.

Marcus had paid for the construction of a theatre at Brough in AD 139 as part his role in the civic government. It was one of the expected duties of elected officials to contribute some of their own wealth for public benefit.

Marriage

Marriage was also an important social status, as it initially conferred the benefits of citizenship on children from parents who were both citizens. Soldiers were forbidden to marry until the third century AD, but it is obvious that unofficial marriages and relationships would have taken place regardless. Tombstones were often dedicated by

the mourning partners of the sadly departed. We have seen, in an earlier chapter, the relationships of those making the dedications to the deceased. *Coniunx* is the Latin word for 'partner' that appears on many of the surviving tombstone epitaphs.

Small objects could be given as love tokens, and some may have been used as gifts of a marriage proposal or of signifying an 'unofficial' marriage if it was legally unpermitted at the time. A silver finger ring depicting the *dextrarum iuncto* was found in 2019 near Beverley. The ring dates to the second century AD. The phrase can be loosely translated as 'joining right hands'; on the image there are a pair of right-hands about to join, as if shaking hands. The use of the right hand is important as a symbol of marriage because of the Roman superstition that *dextrarum* (right) was regarded as auspicious or lucky and *sinister* (left) as the opposite – it's like a modern wedding celebration bedecked with images of lucky horseshoes. The silver ring is particularly worn, suggesting that it had a long life and, perhaps, this is because of the long and happy relationship of its owner.

A jet pendant, probably from York, shows a classic portrait of a couple facing each other. It was probably like a modern locket containing a photograph – a keepsake for one of the two people depicted in the scene. It is quite a formal scene, but the couple are squeezed up next to each other and are turning their gaze towards one another. Examples from elsewhere in Britain show a couple kissing.

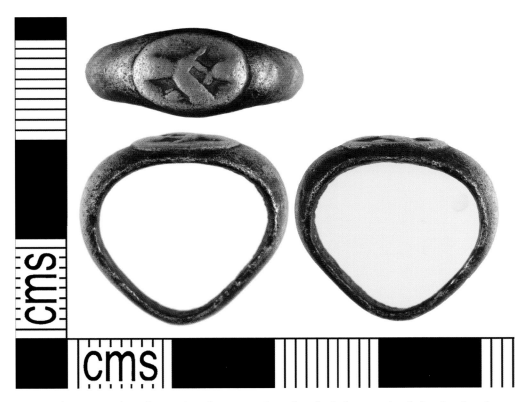

A second-century silver finger ring from near Beverley depicting a pair of clasping hands – a probable betrothal token (PAS: YORYM-712B4). (© York Museums Trust, CC BY 2.0)

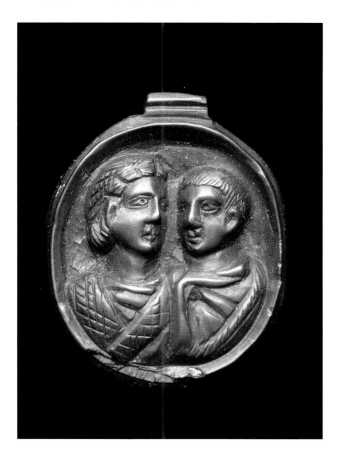

A portrait pendant, probably from York, depicting a couple around the third century AD. In the Yorkshire Museum (YORYM: H2442). (© York Museums Trust, CC BY SA 4.0)

The visual and textual evidence in Britain highlights only the heterosexual relationships, though we can be certain that same-sex and other relationships existed in the ancient world. For example, there are many possible explanations for the relationship between two men found in a single grave at Trentholme Drive, York – one in his late teens having his shoulder clasped in a protective embrace by one in his early twenties – but the idea that they were in a relationship shouldn't be discounted.

Children

Material evidence for children is very difficult to find, and it may be distressing to rely on the archaeology of graves to account for their presence in Roman Yorkshire. Their presence is attested on many of the tombstone epitaphs above – Simplicia Florentina at York, for example. A small group of figurines depicting bears and big cats in Britain seems to be closely associated with young children. These are all made from Whitby jet, the electrostatic properties of which have already been mentioned. They may have been amuletic but could also have been toys. There are more in the south-east, but example in Yorkshire are known from York and Malton.

Very few animal figurines in jet are known from Roman Britain, but one of these incredible objects survives from Malton, which was probably an important place for the production and transportation of Whitby jet. In the Malton Museum. (Reproduced by kind permission of Malton Museum CIO. All rights reserved)

The Enslaved

It is important not to ignore the role of slavery and the prominence of enslaved people in the ancient world. In somewhere like York we shouldn't think that there were only one or two people owned by the wealthiest, but hundreds of people forced to become enslaved to serve Roman society. There were numerous paths into slavery, notably captives from Rome's many wars and invasions, but financial ruin could lead to it, and a child born to an enslaved person was also enslaved. The enslaved could be domestic servants and many educated enslaved people could be tutors, physicians, or accountants. Many were forced to work as labourers to maintain sewers, construct buildings, operate public facilities like the baths, or worked on farms. By all accounts the worst place to be enslaved was in a mine: this job was used as a drawn-out death sentence in the Roman world. Nikomedes dedicated an altar in York to the goddess Britannia. He named himself as a 'freedman of our Emperors' and was probably owned by the state, performing some sort of administrative role, before he gained his freedom.

There were ways out of slavery, as the goldsmith shop given to the enslaved person at Malton might attest to (see following), and the enslaved could buy their freedom if they were able to gather enough money to do so. Biographies of people in this situation are very hard to

88

Enslaved captives, bound at the neck with chains, was used to decorate this Samian ware bowl. Railways Excavations, York. In the Yorkshire Museum (YORYM: H32). (© York Museums Trust (CC BY SA 4.0)

find. Some of the clearest evidence comes from those who had been freed. Caecilius Musicus, freedman of Caecilius Rufus, dedicated the sarcophagus of his master's wife Aelia Severa at York. Note the use of the same name – Caecilius. The enslaved usually only had one formal name and adopted the family name of their enslaver upon the grant of freedom. Their given names were sometimes humiliating (Felix, Latin for 'lucky', was popular) or descriptive of their role in the household. Musicus is Latin for 'musician', and this might have been his job.

Malton Goldsmith

An 1814 discovery while digging the foundations for a new church at Norton, near Malton provides an incredible insight into the biography of one tradesman:

FELICITER SIT
GENIO LOCI
SERVVLE VTERE
FELIX TABERN
AM AVREFI
CINAM

Good luck to the genius of this place. Young slave use to your good fortune this goldsmith's shop.

An inscription plaque dedicating a goldsmith shop to a young slave from Malton. In the Yorkshire Museum (YORYM: 2002.417). (© York Museums Trust, CC BY SA 4.0)

This dedication stone tells us many important things: that there was a dedicated jeweller's shop in the provincial town of Malton, that it specialised in gold jewellery, and that it was run by an enslaved person. It might allude to their manumission (freedom) given upon the death of his or her enslaver. This was a common practice in the ancient world. They may have inherited the business to set themselves up in life subsequently.

Literacy

Levels of literacy in Roman Britain are very difficult to establish because the writing itself was usually on ephemeral materials like wood or wax. Already we have established that there was a tradition of writing inscriptions on tombstones, religious dedications, and on some buildings, and some potters used stamps, but this doesn't get us much closer to day-to-day writing. The fort at Vindolanda, near Hadrian's Wall, has produced incredible evidence of wooden tablets preserved with their inked messages still readable. They contain personal messages, shopping lists, and reports on military strength. Fragments of two writing tablets were found within a communal pond or waterhole at Shiptonthorpe.

They were recessed and so probably held wax, onto which a message could be written – many *styli* are known from Roman Britain with a pointed end to inscribe onto wax and a wide, spatula-like end that could be heated to erase the writing. Writing tablets like this could be used again and again. These two were probably made from a recycled wooden barrel.

Ceramic vessels sometimes display evidence of names or messages. From York a Samian ware bowl is inscribed with the female name Candida on the base and a mortarium was inscribed with Crisp[us]. At Castleford a Samian ware dish belonged to Firm[us] and one at Doncaster to Adiutor.

Writing tools and implements can also be found, like the *styli* used to write on the wax tablets, and seal boxes. A seal box contained several holes so a cord can be passed through it and wrapped around its cargo before wax was melted within the box and a seal impressed onto it. They each had a hinged lid, so that the seal was protected during transit.

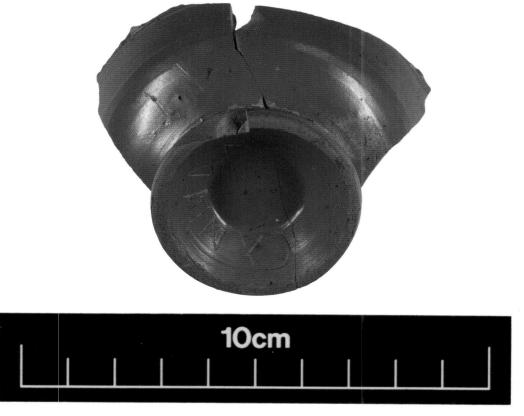

This small Samian ware cup from York has been inscribed on its base with the name of its owner – Candida. In the Yorkshire Museum (YORYM: 1971.299.3). (© York Museums Trust, CC BY SA 4.0)

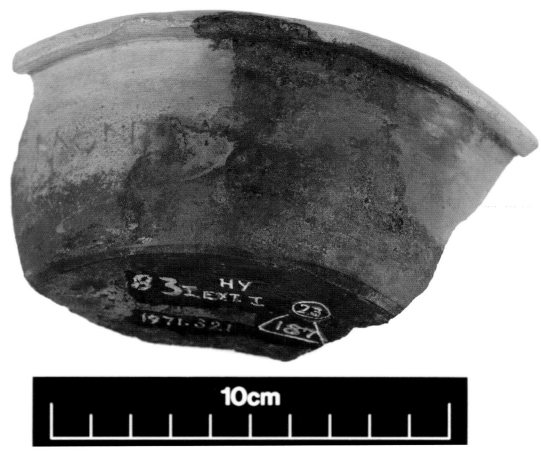

This dish from Hungate, York, is inscribed across its exterior – plainly for all to see. In the Yorkshire Museum (YORYM: 1971.321.187). (© York Museums Trust, CC BY SA 4.0)

A seal box from Boroughbridge, North Yorkshire. The holes in the back were for a cord to pass through to connect the box to its payload, which was then sealed with wax. The small panels on the front were filled with colourful enamel (PAS: SWYOR-7E3EFA). (© West Yorkshire Archaeology Service, CC BY SA 4.0)

Appendix I

Finding Romans

Where to See Romans in Yorkshire

There are some amazing standing remains of Roman buildings in Yorkshire, but they are spread across the region and weighted towards those in North and East Yorkshire. Top of the list for a visit to a Roman site must be York. The famous Multangular Tower stands in the museum gardens. Other fragments of the fortress and *colonia* walls are dotted around – these were the basis for the medieval walls, which can still be walked across in a circuit around most of the Roman extent of the city. The remains of the legionary bathhouse are also visible under the Roman Bath pub and parts of the *principia* in the undercroft of York Minster. At Aldborough there are two mosaic pavements still in situ and a small on-site museum, making this a great stop off on a trip along Dere Street. Fragments of defensive

The tombstone of Julia Velva shortly after its excavation in the nineteenth century. (From the archive of the Yorkshire Museum)

earthworks can easily be seen at Malton and the same is true of the temporary camps at Cawthorn Camp. The coastal signal station at Scarborough is the easiest of these to access. Iron age earthen fortifications can be found at the top of Ingleborough and at Stanwick St John.

Museums

Roman remains can be found in many of the regional museums in the counties of Yorkshire, particularly: Yorkshire Museum (York), Leeds City Museum, Weston Park (Sheffield), Scarborough Castle, Malton Museum, Doncaster Museum, Skipton Museum, Wakefield One, Hull and East Riding Museum, and Castleford Forum.

There is a long tradition of Roman archaeological museums and displays in Yorkshire. Here, a mosaic and ceramic vessels from York can be seen on display in the Yorkshire Museum in the early twentieth century.

Bibliography

Websites

There is a huge amount of archaeological data available on the Portable Antiquities Scheme website (www.finds.org.uk). The PAS records archaeological objects found by members of the public in England and Wales and particularly works with the metal detecting community. There are over 1.5 million objects recorded on their free-to-access database.

The Roman Roads of Britain online resource is the best free information source on Roman Roads in this area (roadsofromanbritain.org/yorkshire).

Further Reading

Bidwell, P. and N. Hodgson, *The Roman Army in North England* (2009)
Bishop, M. C., *The Secret History of the Roman Roads of Britain* (2014)
Halkon, P., *The Parisi: Britons and Romans in Eastern Yorkshire* (2013)
Hartley, B. and L. Fitts, *The Brigantes* (1988)
Hoffmann, B., *The Invasion of Roman Britain: Archaeology vs. History* (2013)
Mattingly, D., *An Imperial Possession: Britain in the Roman Empire* (2006)
Ottaway, P., *Roman Yorkshire* (2014)
Parker, A., *The Archaeology of Roman York* (2019)

The Archaeology of Roman York

Adam Parker

This book introduces the archaeology of Eboracum. A fascinating
look at the rich Roman history of York.

978 1 4456 8607 3
96 pages, full colour